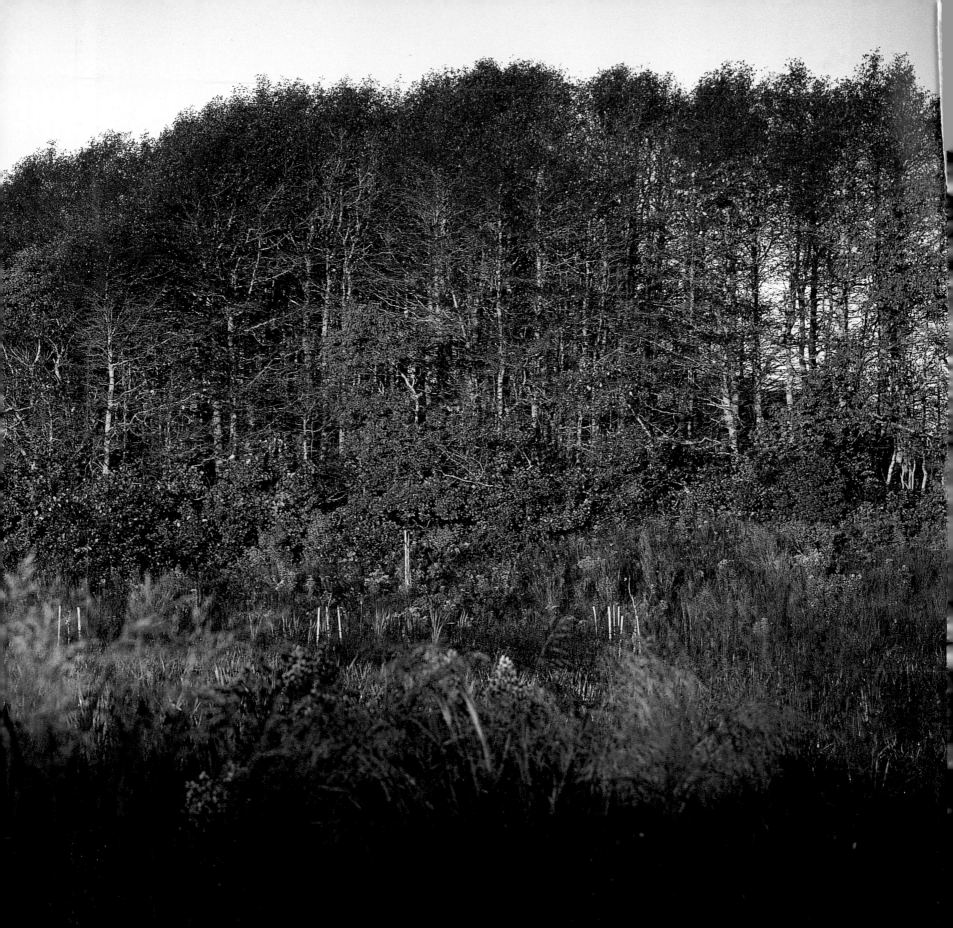

NANTUCKET

NANTUCKET
the quiet season

CARY HAZLEGROVE Foreword by Nathaniel Philbrick

CHRONICLE BOOKS

SAN FRANCISCO

Library of Congress Cataloging-in-Publication Data available.

ISBN 0-8118-4518-4

Manufactured in Hong Kong.

Designed by Chen Design Associates, San Francisco

Distributed in Canada by Raincoast Books
9050 Shaughnessy Street
Vancouver, British Columbia V6P 6E5

10 9 8 7 6 5 4 3 2 1

Chronicle Books LLC
85 Second Street
San Francisco, California 94105

www.chroniclebooks.com

page 2:
Tupelo Trees

To the quiet of the off-season

and to my daughter Virginia, who warms my winter heart.

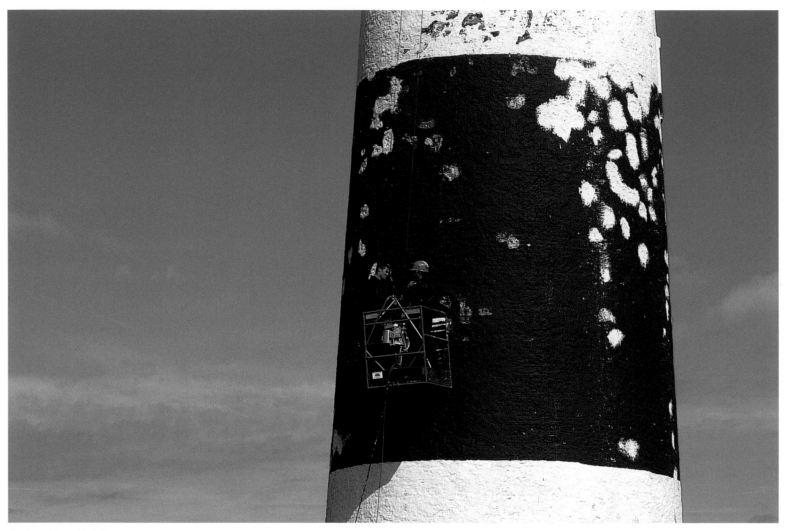

Sankaty Head Lighthouse

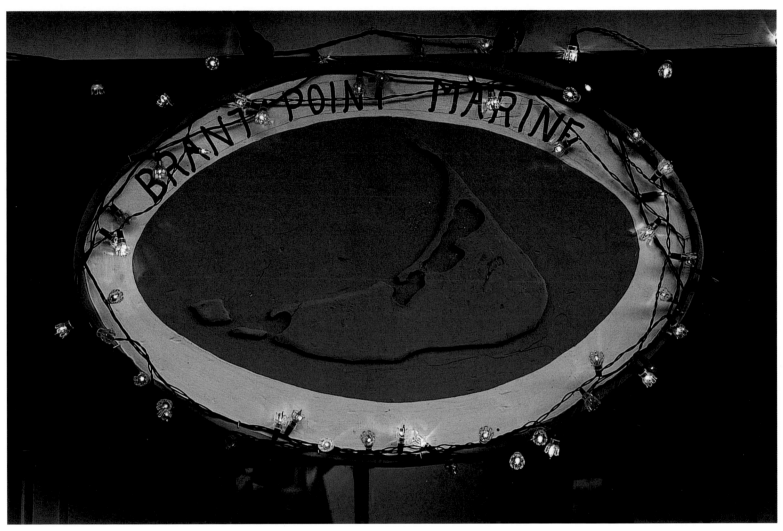

Brant Point Marine

Everyone thinks something when they hear the word "Nantucket."

Robert McKee, ARTIST

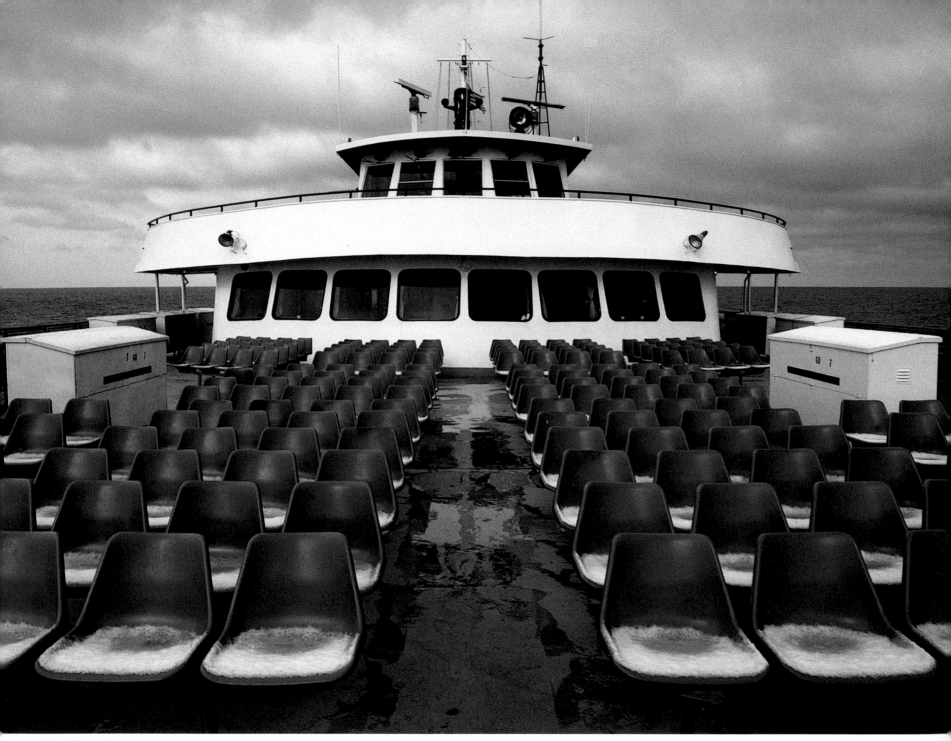

M.V. Nantucket

PREFACE

Nantucket is cold and gray and the harbor is frozen. The boat has not run since Saturday, and the bread shelf at the grocery store is well picked over. The island is surrounded by large ice floes, and the wind never stops. This is my favorite time.

Living on an island is not for everyone, and living on Nantucket Island year-round is *really* not for everyone. Summer, although beautiful, brings an invasion of strangers and traffic, and we collectively yearn for fall. There is no real Nantucket spring, and winter lasts forever.

Nantucket gives us fall as a gift for surviving the summer months. It marks the beginning of a quieter time. Winter is more controversial and the most talked-about season of our year. People always ask me, "What do you do in the winter?" Everyone who visits Nantucket wants this question answered, as if the sidewalks magically roll up after Labor Day. Winter is endured by some and lovingly embraced by others, but it is not for the fainthearted. You have to be independent, resourceful, and, as my friend Christine Mallia says, "satisfied with nature as entertainment."

Living on an island in the North Atlantic in the off-season conjures images of isolation and desolation. We are enveloped by a continuum of gray and very little color—a stark contrast to the vibrant greens and blues that summer provides. But this is the time when I feel most connected to the Nantucket landscape. Winter is when Nantucket truly unfolds. She is down to her bones—barren, windswept, and steadfast—revealing her poetic side.

I have lived and photographed on Nantucket for more than half my life. In this often bleak, color-starved landscape, I have learned to appreciate the small and subtle things that make Nantucket a unique place—things that might be deemed common or trivial or lost in a larger environment. My perception of beauty has been inspired and formed by my life here, and I am honored to call this home.

Cary Hazlegrove

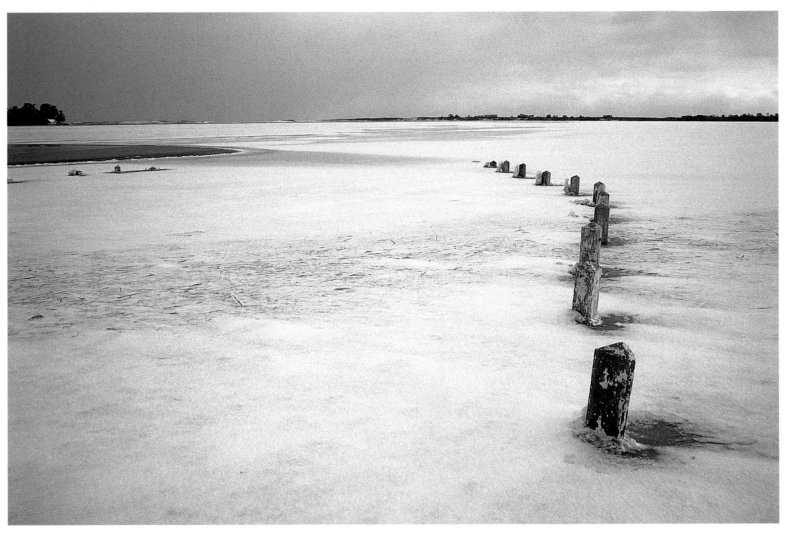

Sesachacha Pond

FOREWORD

I've often thought it lucky that my wife and I and our two children moved to Nantucket in September. Instead of the crowds of summer, it was the island itself that dominated our first year here as a family. We soon discovered that Nantucket is much more than a fifty-square-mile backdrop to its beaches.

Curled protectively inward against the open Atlantic to the south and east, Nantucket is an undulant crescent of grasslands, heathlands, bogs, marshes, woods, and ponds. After seventeen years of walking the island's many trails and back roads, I'm still stumbling across places that I didn't know existed. My favorite way to explore Nantucket is by water—either in a kayak or small sailboat. Nothing can compare to pulling into a tiny, wind-protected corner of the harbor on a crisp fall day to bask in a slanting shaft of mellow afternoon sun.

And yet, to understand what Nantucket truly is, you must venture to its wave-battered perimeter. It's the ocean that transforms what would otherwise be a fairly unexceptional patch of grainy earth into something special: an island almost thirty miles out to sea. Standing on Surfside Beach in December—the gentle

sandy slope of summer blasted into a crumbling cliff by the winter waves—you begin to appreciate why some erosion experts have predicted that the island will be washed away completely in just eight hundred years. Endangered and besieged, Nantucket will always be a kind of hallowed ground—a place where the redemptive forces of community and natural beauty are all the more keenly felt because of the island's proximity to a chaotic wilderness of water.

You might not be able to see the ocean during a fall picnic at the cranberry bogs, but you know it's out there; if the wind is from the south, you can even hear it—a barely discernible roar of waves. Even amid the cobblestoned quaintness of the historic district, Nantucket's link to a distant savagery is inescapable. A former whaling port built on the blubber and bones of sperm whales, Nantucket will always be an island in time. Indeed, without the

above, left to right:
India Street

Bittersweet Wreath

Sankaty Beach Club

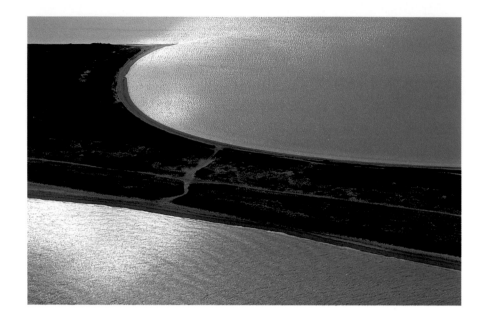

ferocity of Nantucket's whalers, there would not have been these
elegant houses—enduring monuments to the Quaker ideals of
spirituality, sanity, and peace.

Since it is an island, and an eroding island at that, the weather
has always been a large part of life on Nantucket. That's why the
Weather Channel is the only reality show that matters on the
island. Nothing is better for a Nantucketer's morale than an
approaching storm. It gives the days a plot line, and each storm
becomes its own little epic. In the last decade and a half, we've seen
hurricanes flood Easy Street and a sperm whale wash up at 'Sconset;
we've watched as an entire beachside cottage was swept out to sea
and torn apart by the breakers.

But the months between September and June are not all cataclysm and desolation. The change of seasons on Nantucket is, for the most part, magnificently subtle: the gradual outbreak of autumnal colors on the moors, climaxed by the incandescent red of the cranberry harvest; the unremitting gray of the winter sky; the painfully slow arrival of a fog-shrouded spring; and finally, Memorial Day weekend—the beginning of another strobe-lit summer.

This is the seasonal rhythm that a year-round Nantucketer comes to know and love. Here, for the first time, is a book that chronicles in exquisite color photography what has been fittingly dubbed "the quiet season." For years, Cary Hazlegrove's photographs have been making the island seem new again, even to the most jaded of old-time residents. With this book, she reveals a side of Nantucket that only year-rounders have had the chance to experience firsthand, but which anyone who has visited the island will find fascinating, beautiful, and inspiring. For all those who love Nantucket, *The Quiet Season* is a gift to be treasured—just like a golden afternoon in October before an on-coming gale.

Nathaniel Philbrick
FEBRUARY 14, 2004

opposite:
Coatue

following pages:
Ocean

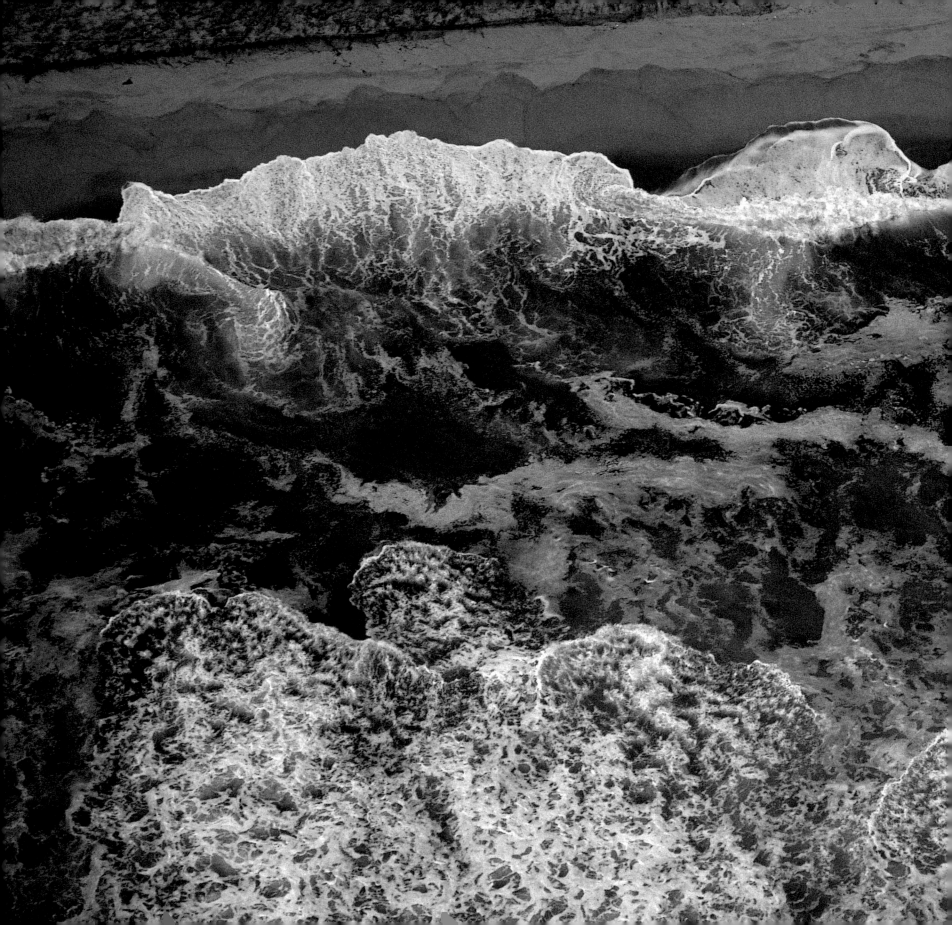

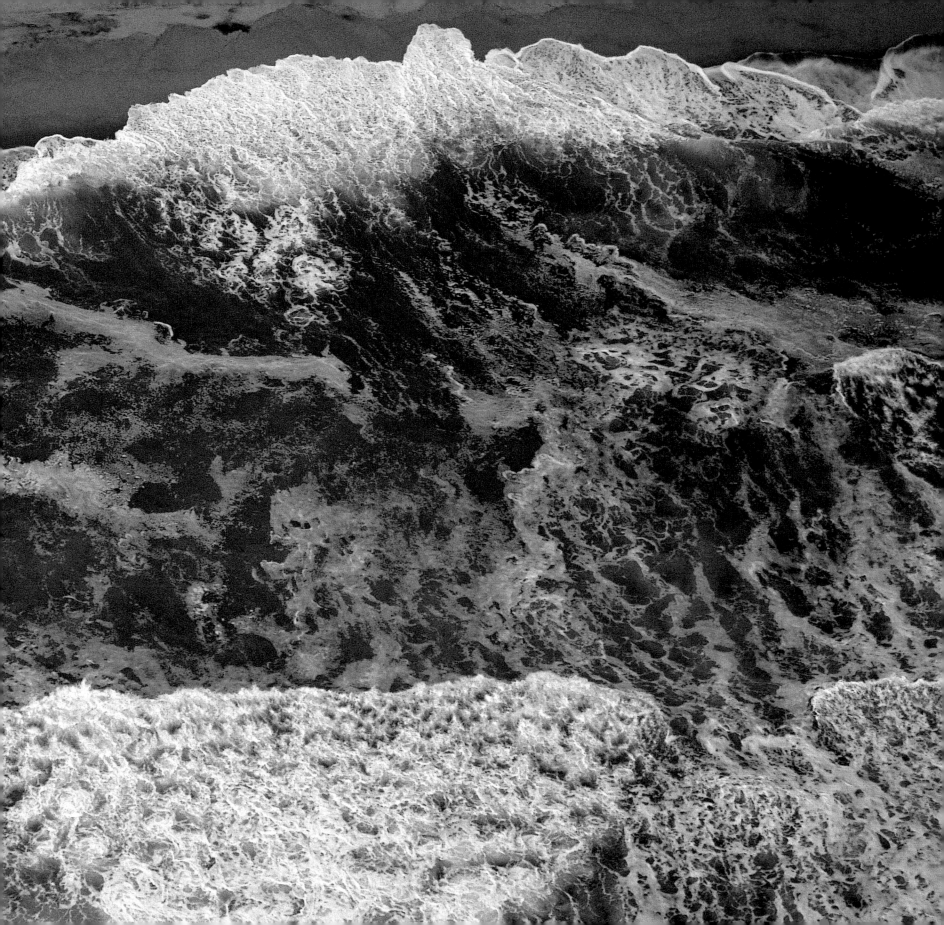

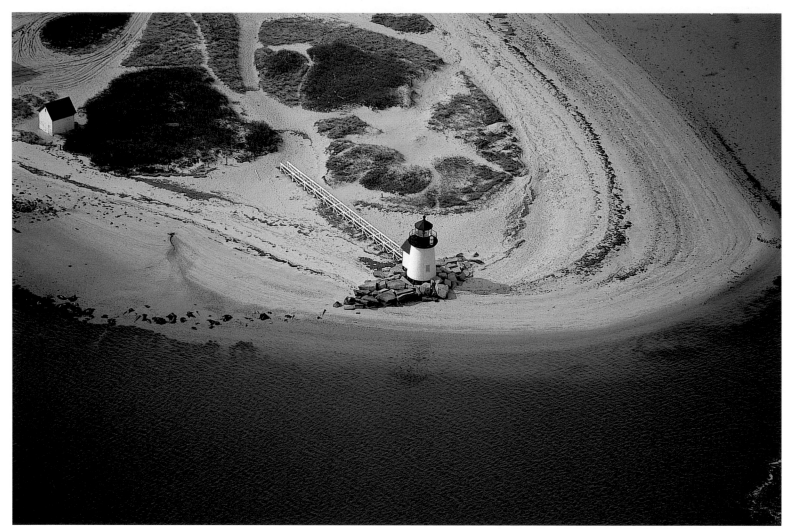

Brant Point Lighthouse

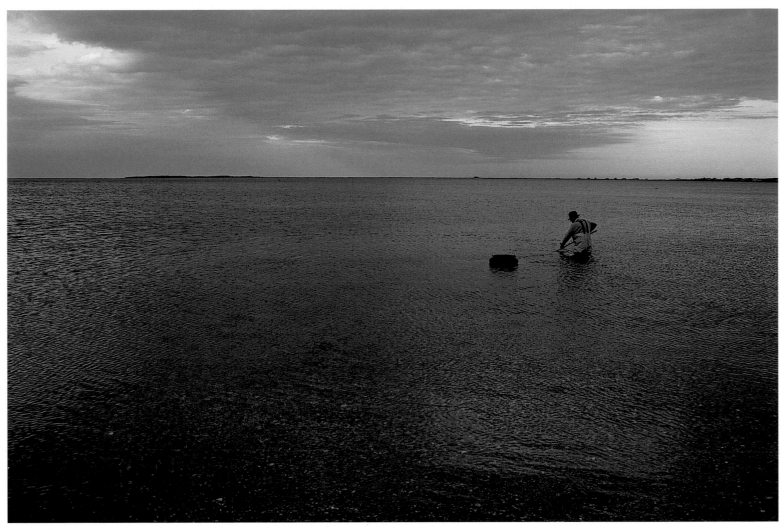

Scalloping, Pocomo

Everywhere you go there is ocean.

Georgia Ann Snell, MINISTER

Poison ivy is our fall foliage.

It is our maple tree.

Skip Cabot, NANTUCKETER

Poison Ivy

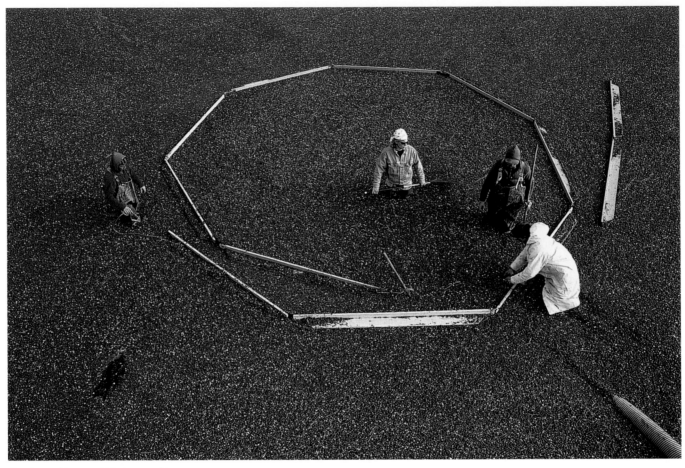

Cranberry Harvest, Windswept Bog

You have to make a niche for yourself, and not everybody is carved out for carving out a niche.

Christine Mallia, MASSAGE THERAPIST

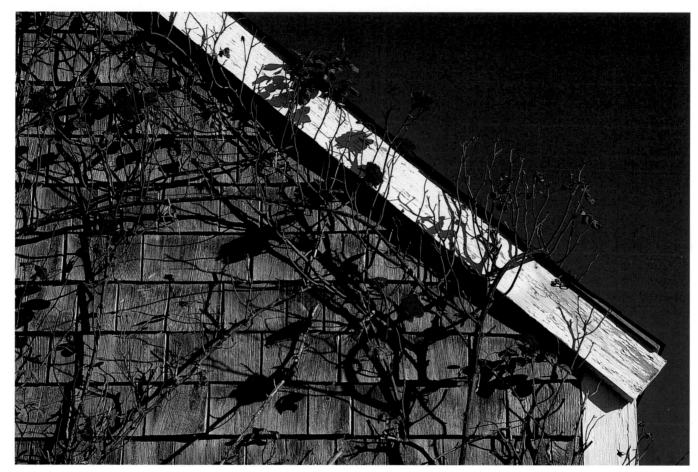

Fall Bloom

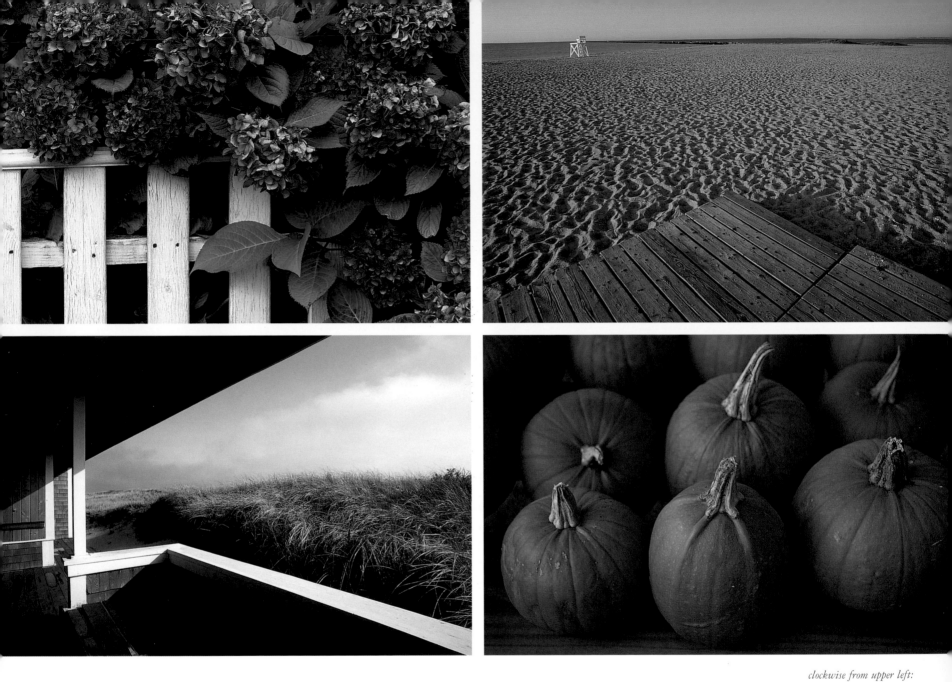

clockwise from upper left:
Autumn Hydrangeas

Jetties Beach

Town Clock

Nantucket Bay Scallops

Washington Street

Cranberry Harvest

Bartlett Farm Pumpkins

Wauwinet

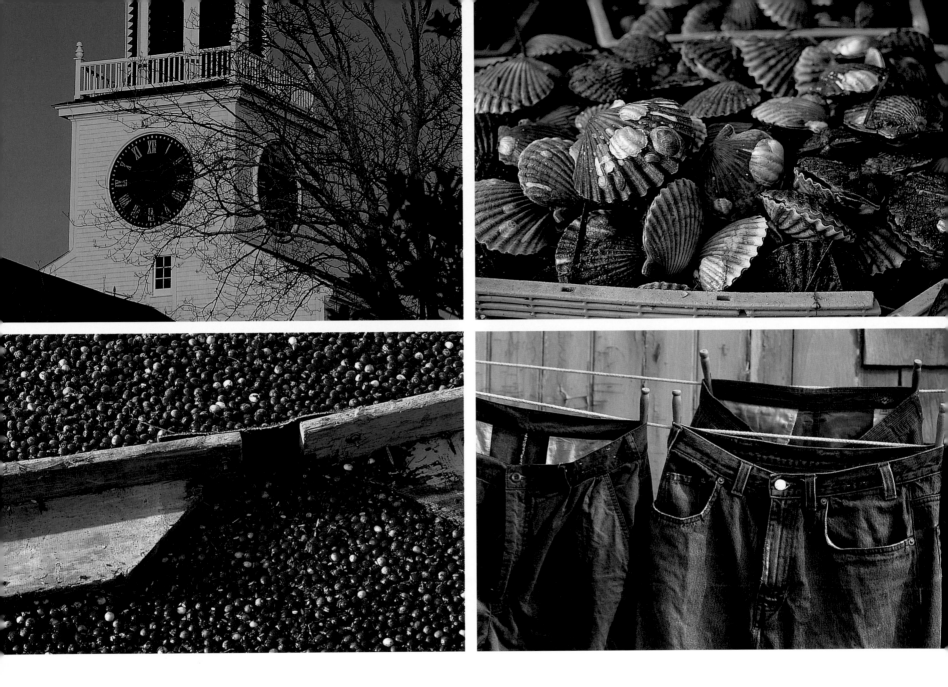

The fall is heaven. It's a reward to the people who live here.

Tom Bresette, FATHER

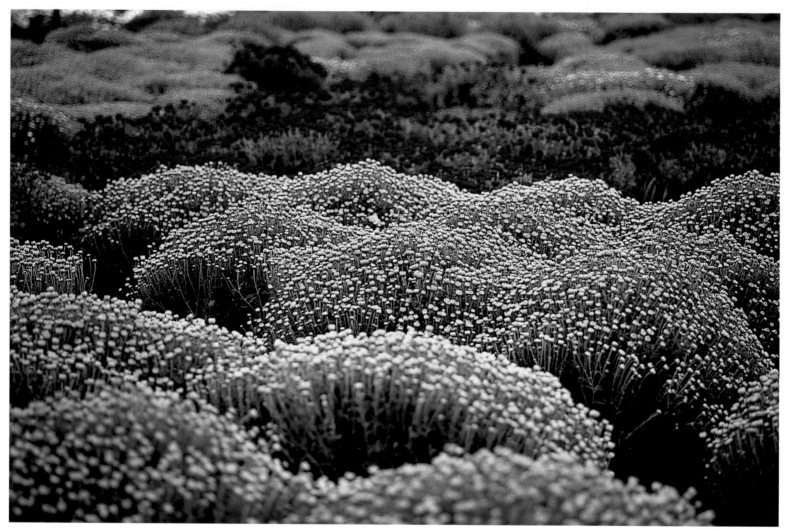

Mums at Bartlett Farm

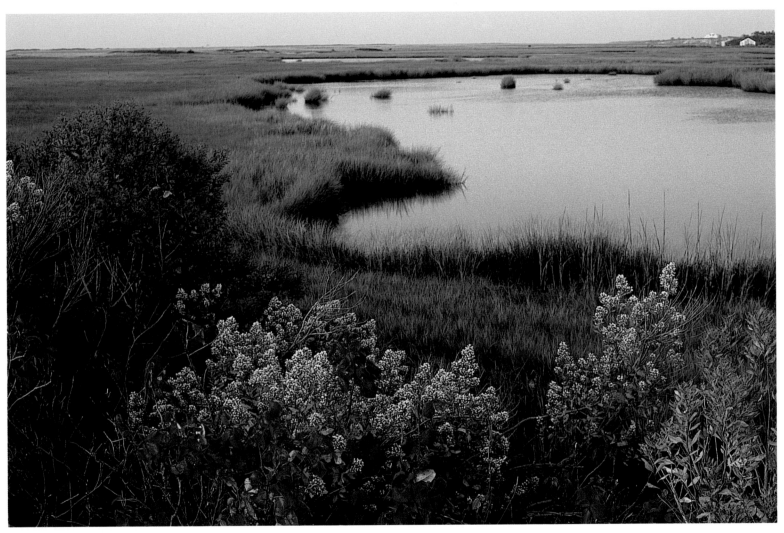

Polpis Inlet

On the mainland, the trees turn different colors in the fall. Here you have to look down to see the fall colors,

which is interesting. You get a unique perspective. There's plenty of color here; you just look down, not up.

Robert McKee, ARTIST

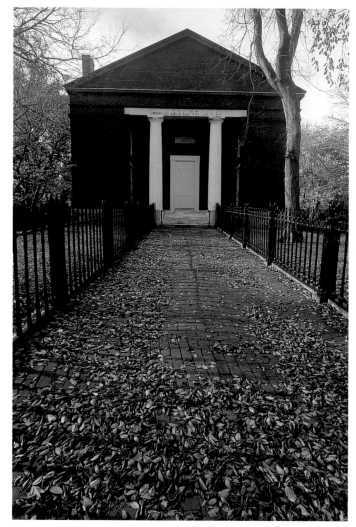

Admiral Sir Isaac Coffin School

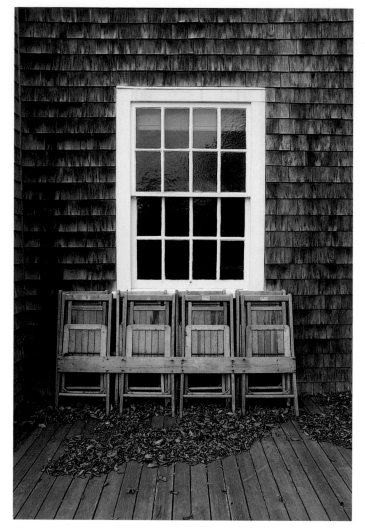

Porch, 'Sconset Casino

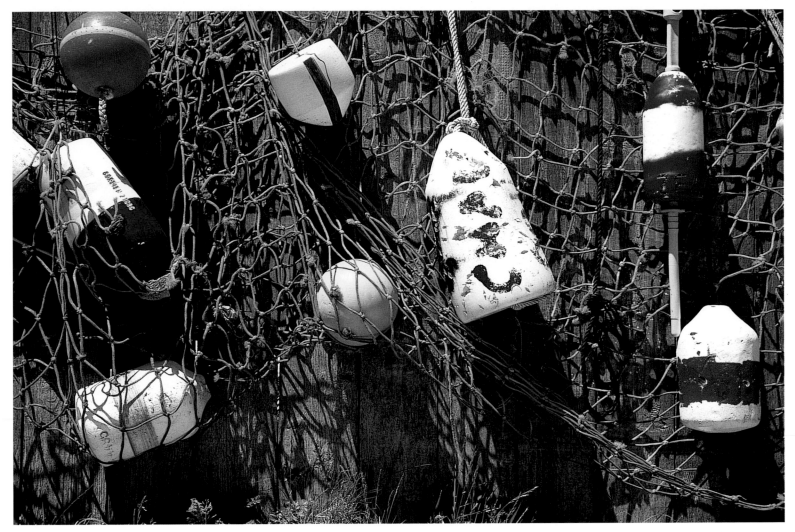

Buoys

Some people come here for a short time and they
think it's a beautiful place and then they move
on to the next beautiful place. But for others,
Nantucket just gets under their skin—they can't
leave, even if they try.

Christie Cure, THEATER FACILITATOR

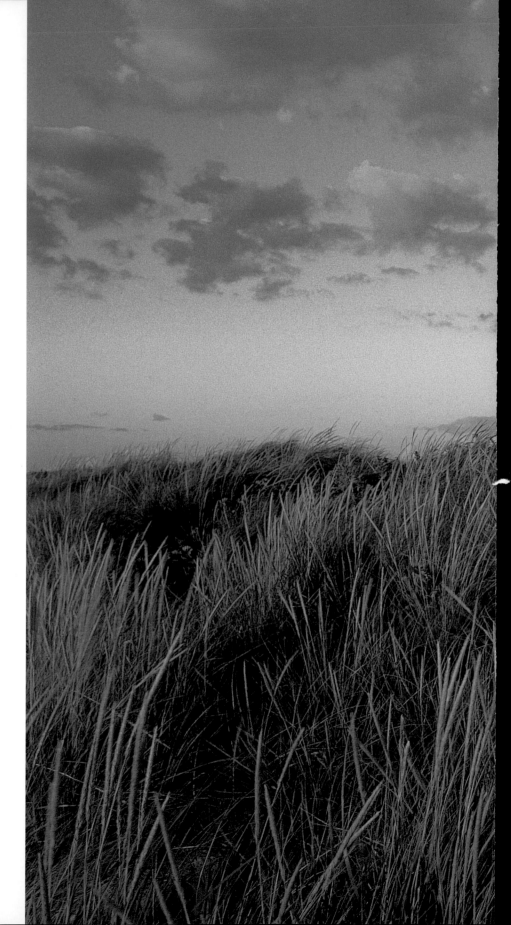

Autumn Beach Grass

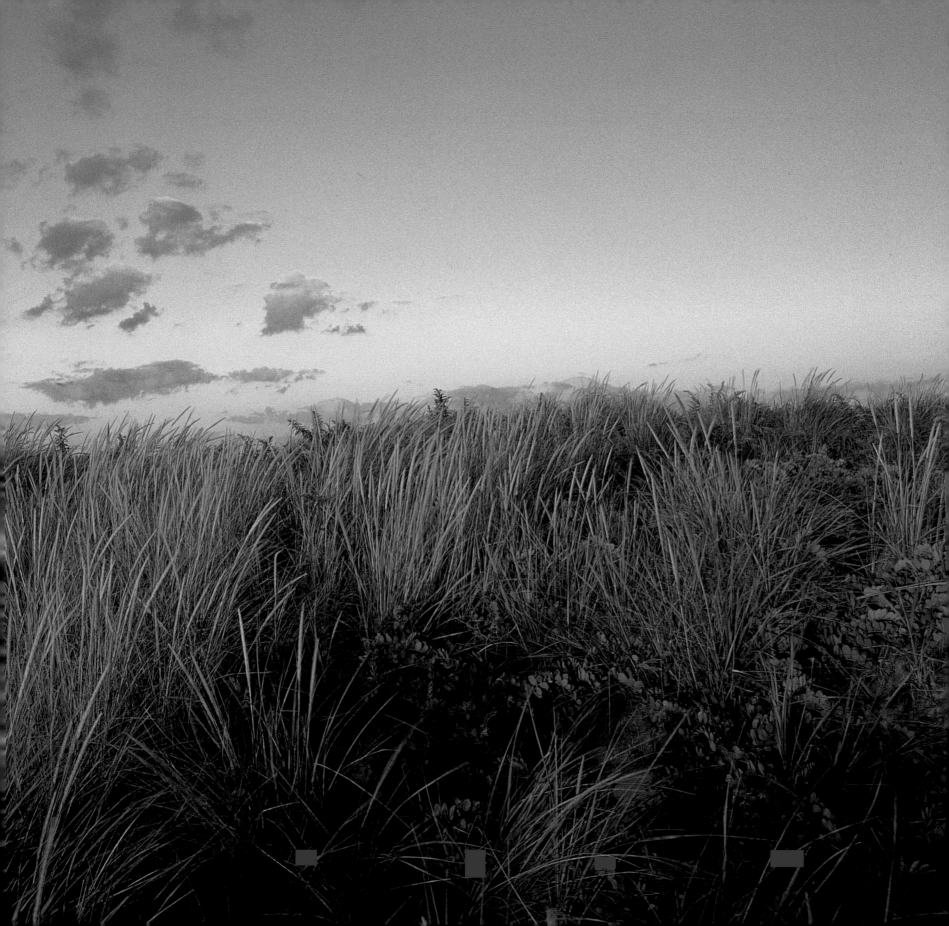

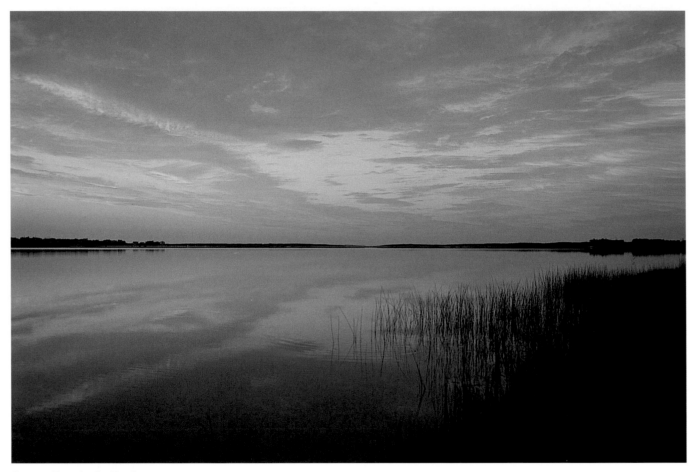

Sunset, Sesachacha Pond

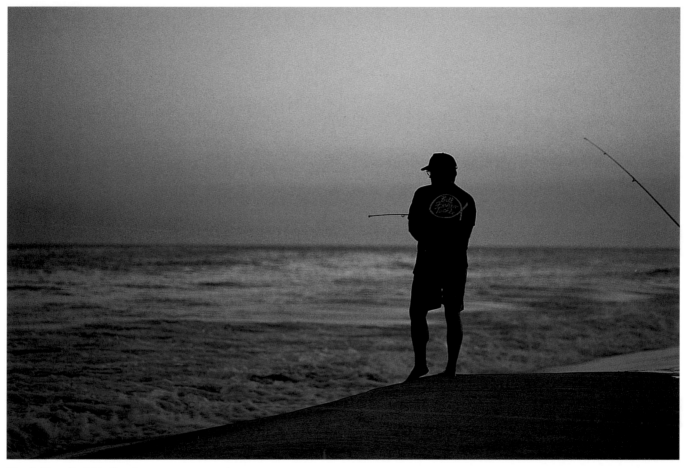

Bluefishing, Surfside Beach

You have to be a particular kind of person to be happy here. I don't think it's for everyone,

because not everyone is comfortable with nature as entertainment.

Christine Mallia, MASSAGE THERAPIST

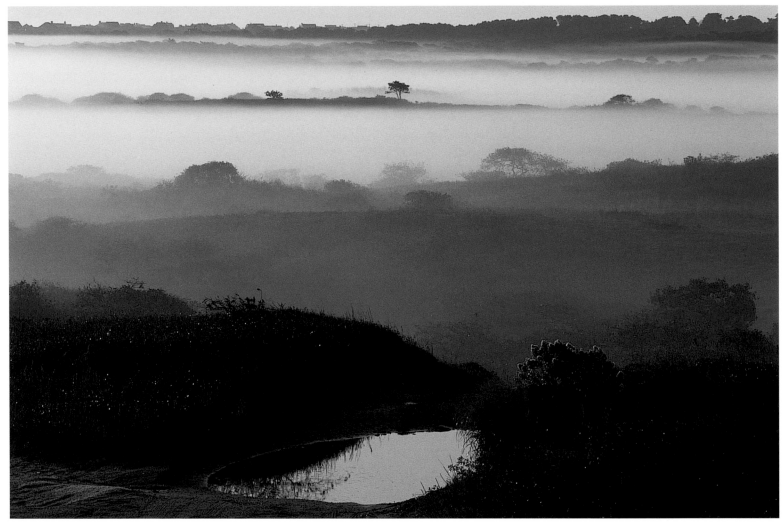

Sunrise, Altar Rock

Nantucket is romantic and ethereal and mythical and mystical. But that it can retain those qualities

for people who have been here for a long, long time is what makes it so special.

Libby Oldham, EDITOR

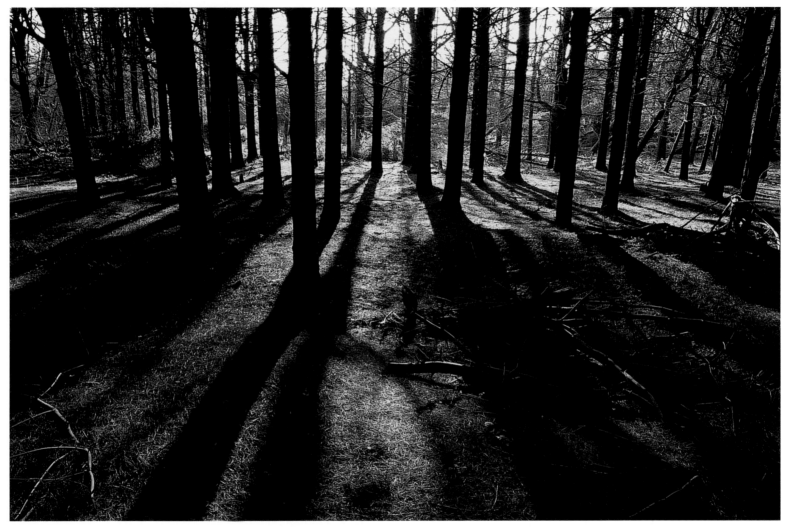

State Forest

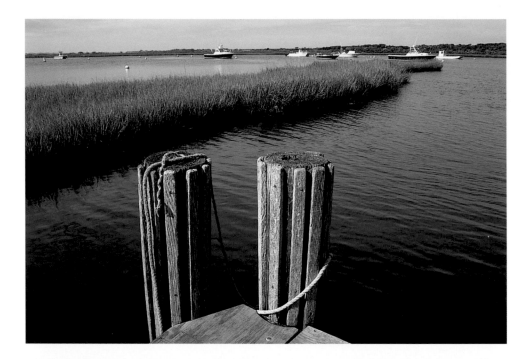

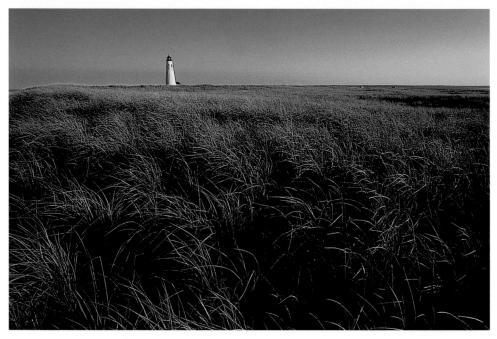

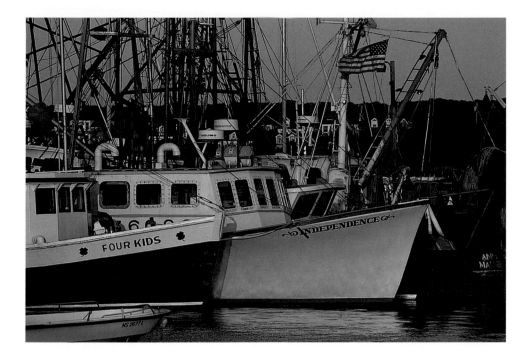

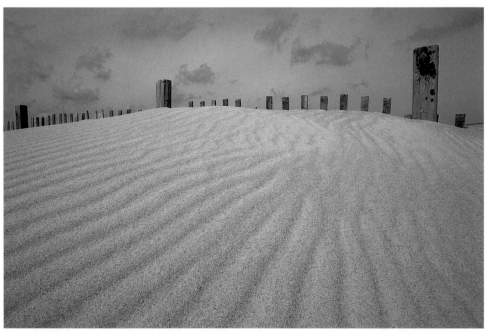

Fall offers a respite from the crowds of summer. We made it through another season, and we get to regroup and reclaim our island. Now I can see people on the street that I know, because they are not mixed in with Them; we are Us again.

Christine Mallia, MASSAGE THERAPIST

above:
Cobblestones on India Street

left:
Pleasant Street

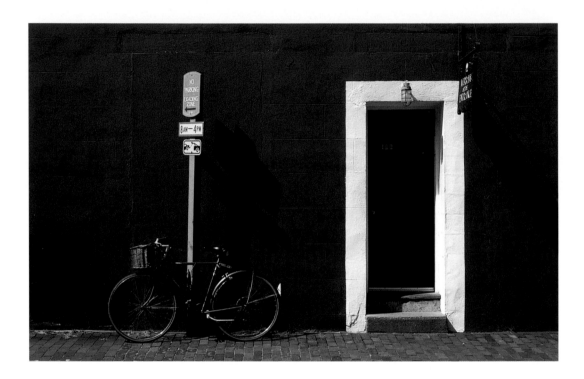

above:

Back Door, Murray's Liquor Store

opposite:

Chanticleer Window

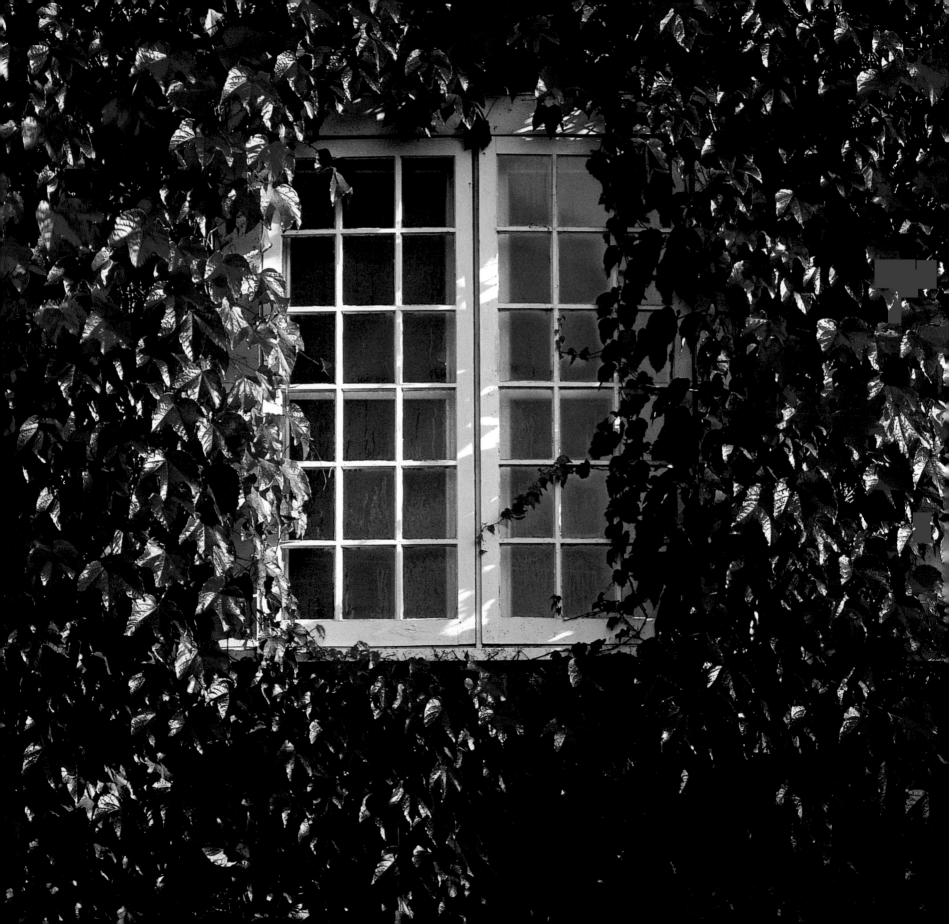

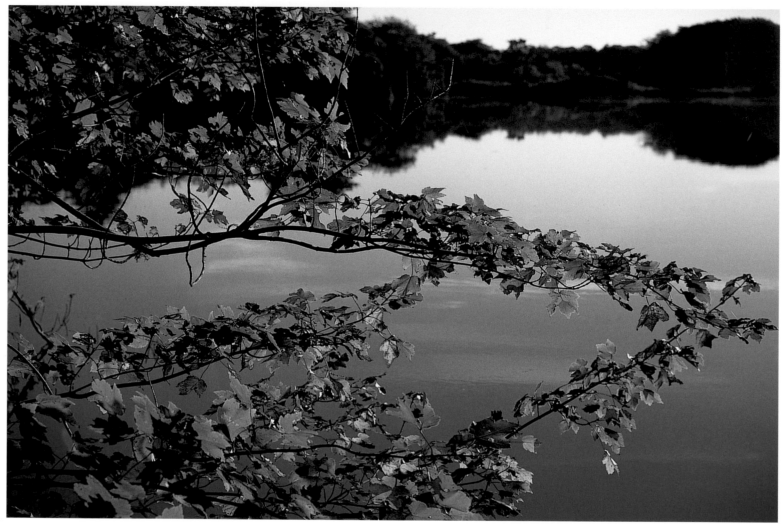

Stump Pond

Nantucket is the only place I am nostalgic for, even when I am on it.

Reggie Levine, ARTIST AND FORMER GALLERY DIRECTOR

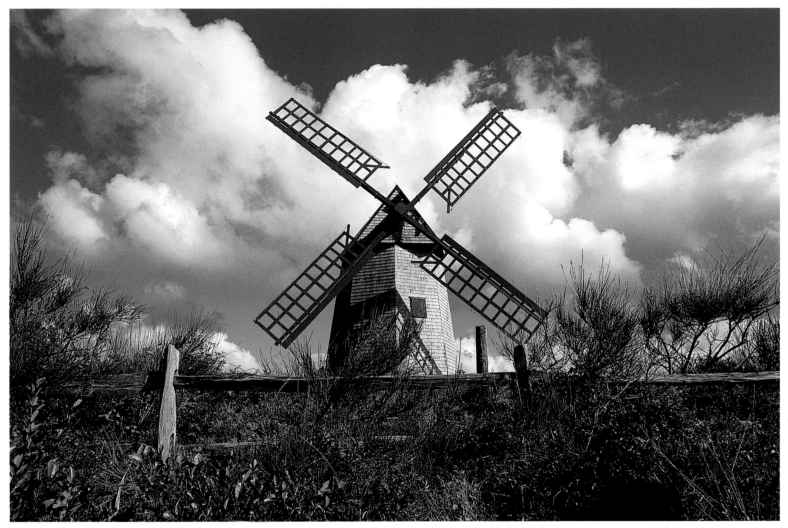

The Old Mill

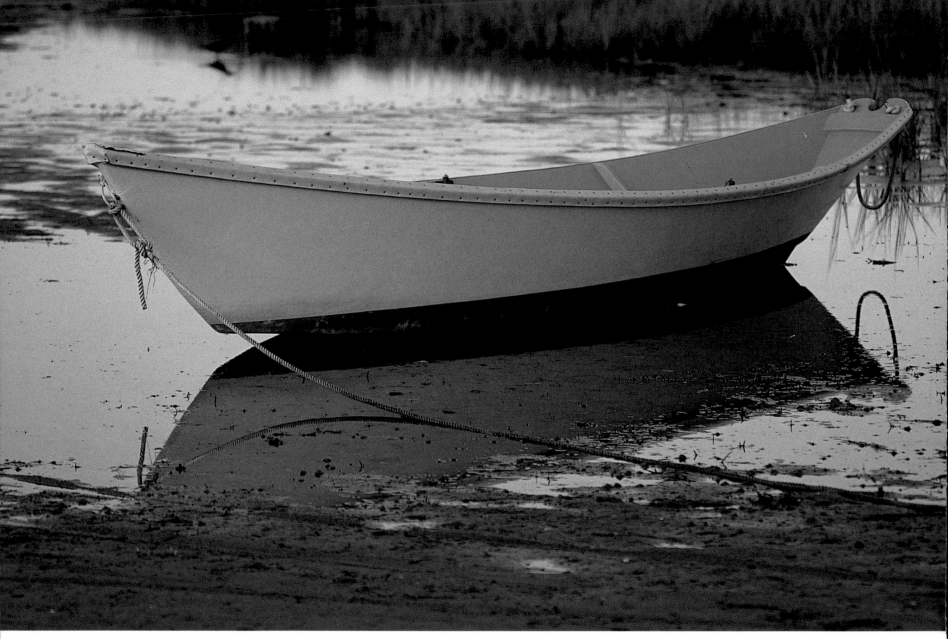

Low Tide, Washington Street Extension

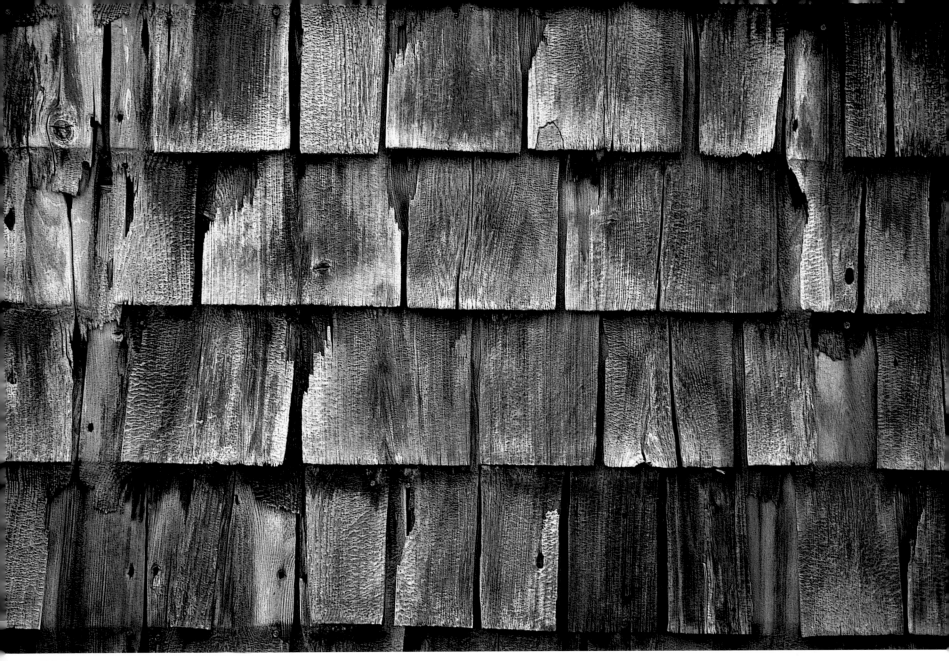

Shingles

We do battle the elements. They are fierce and strong, with high winds and rough, raging seas.

The weather makes us inconsequential, like a star in the sky or a small speck of sand.

Mina Manner, 'SCONSET RESIDENT

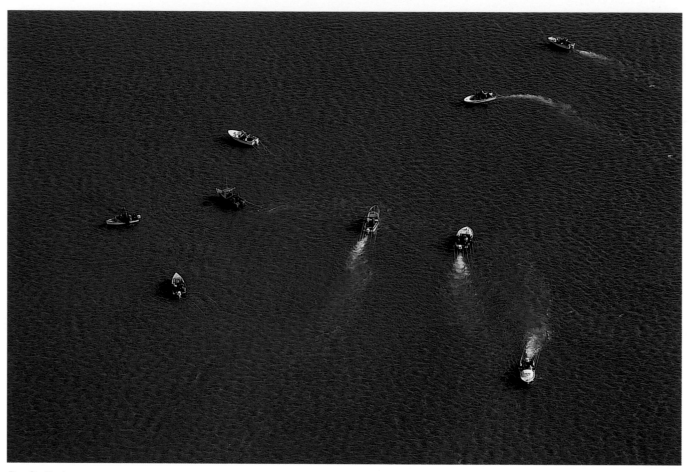

Bay Scalloping

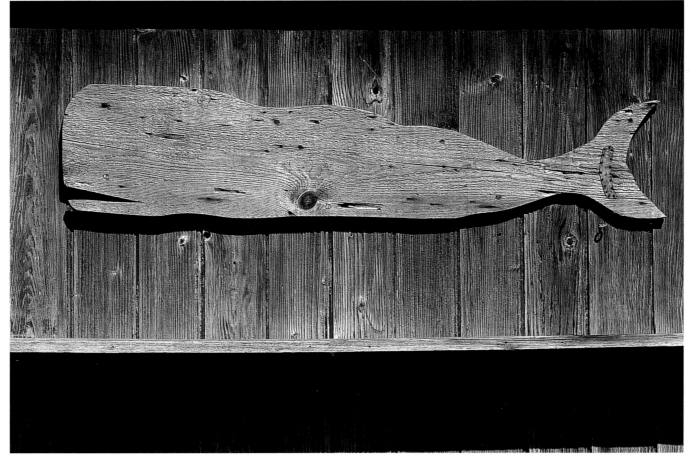

Whale at Salt Marsh Antiques

It's an illusion that Nantucket is a big and important place.

If the ocean sneezes, we are out of here.

Christine Mallia, MASSAGE THERAPIST

Middle Moors

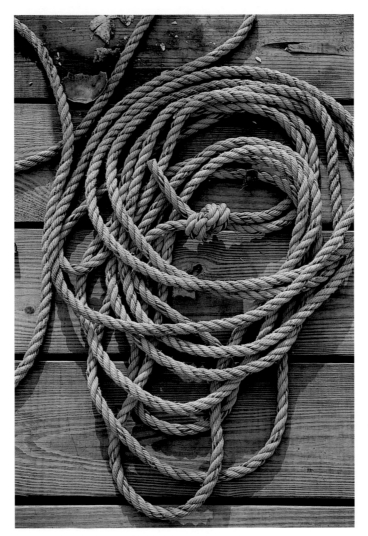

Ropes on Straight Wharf

following pages, left:
India Street

following pages, right:
Skinner's Boat

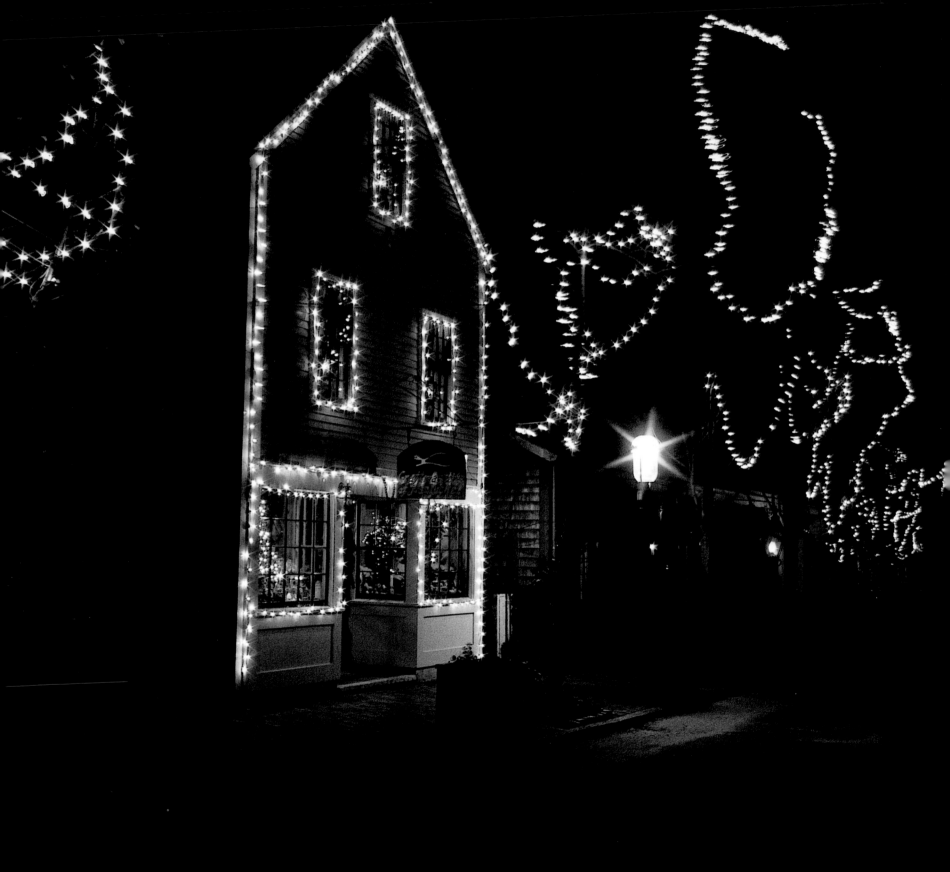

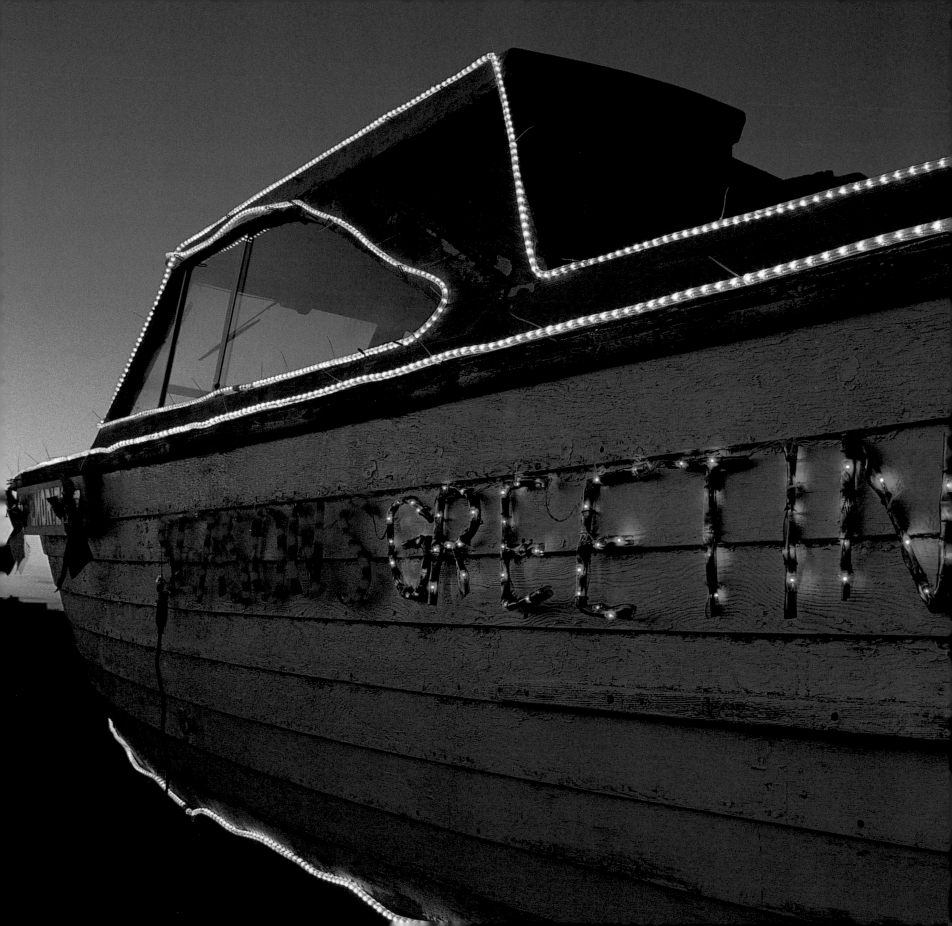

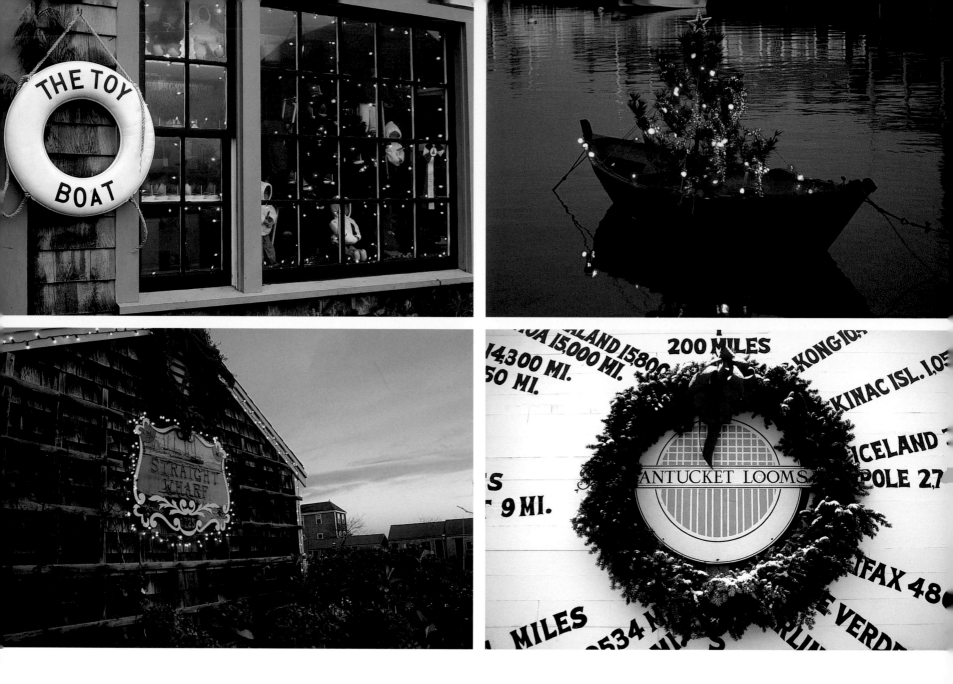

Everything that you envision as a child about what Christmas should

look like and be like is right here.

Robert J. Miller, HAIR STYLIST

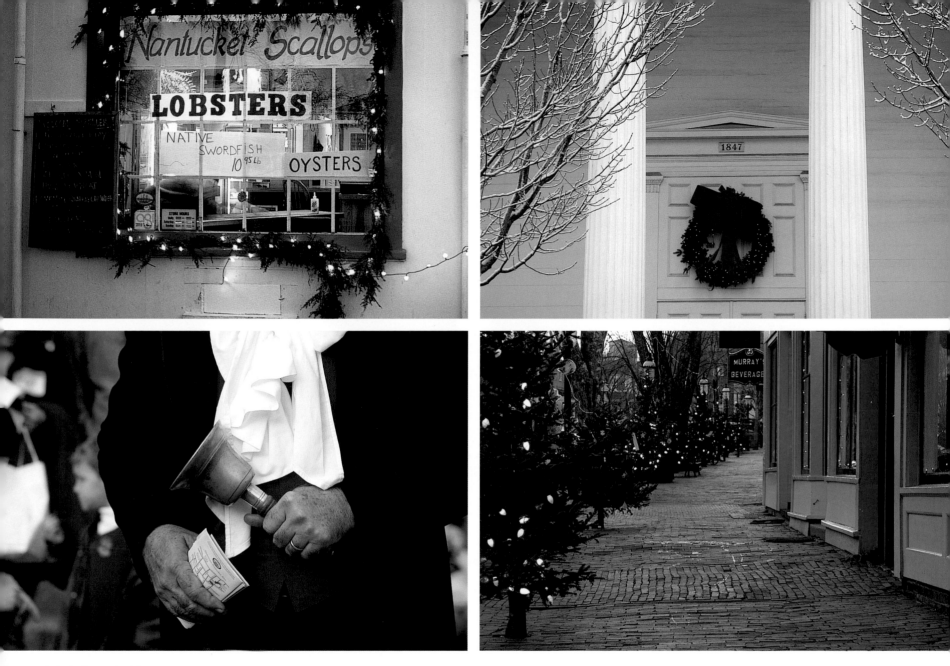

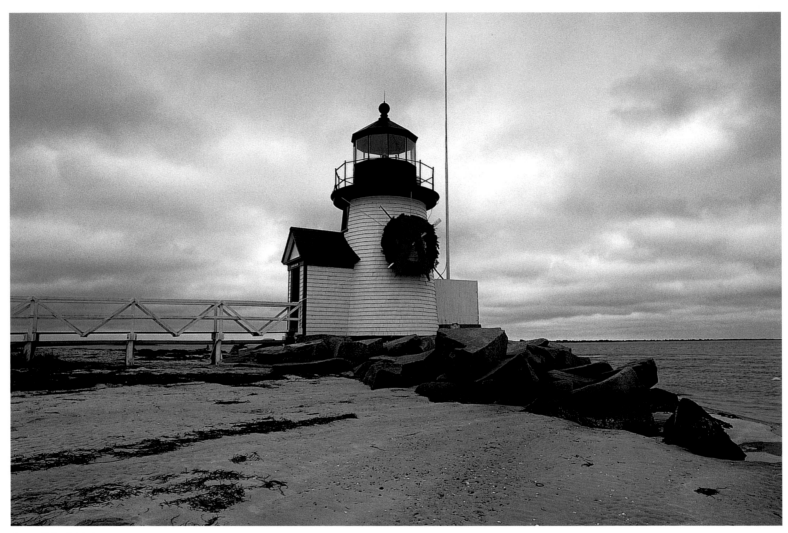

Brant Point Lighthouse

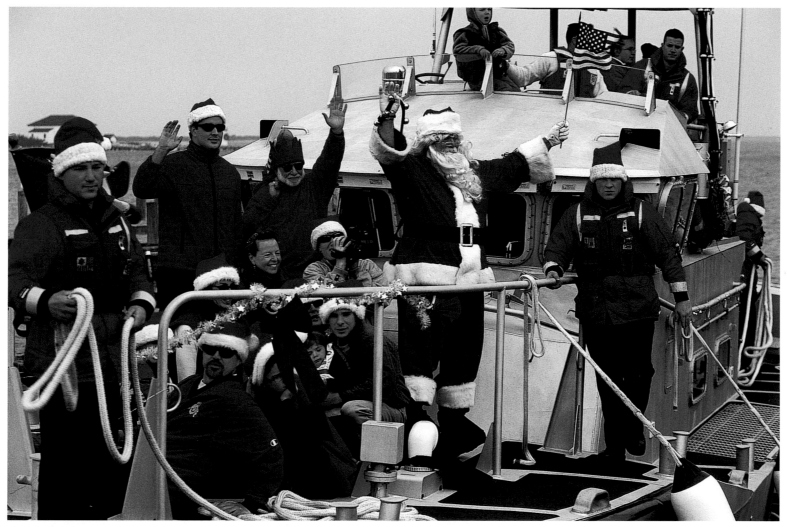

Santa's Arrival

I think it's the absence of formality I like most of all and the relative freedom to be who you want to be.

People are very considerate of eccentricity here.

Libby Oldham, EDITOR

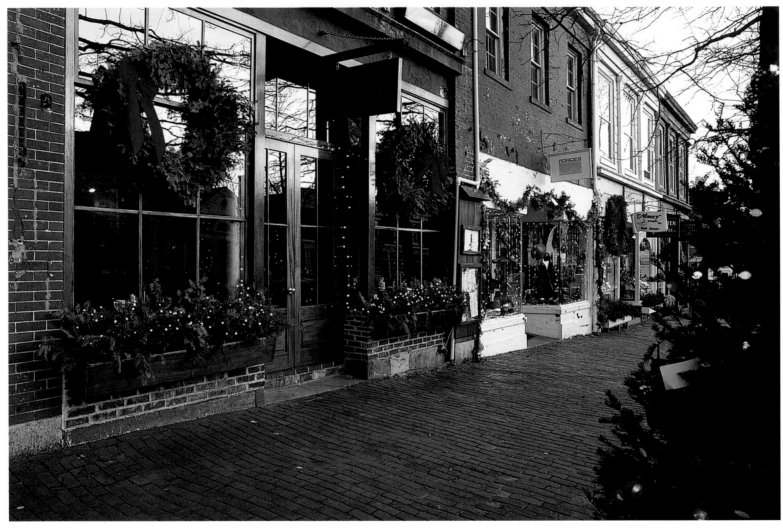

Main Street

I love Christmas on Nantucket. If you stand at the top of Main and you look down the street

in the twilight of a December evening, it takes your breath away.

Finn Murphy, SELECTMAN

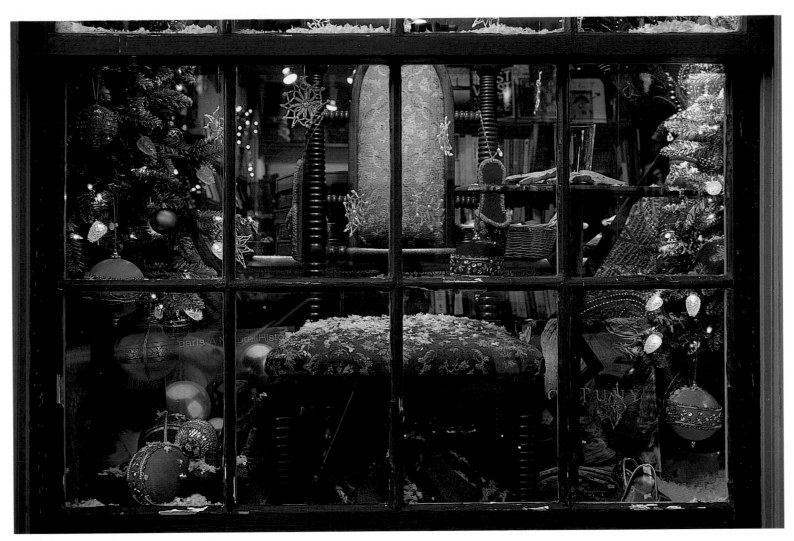

Christmas Window, Bookworks

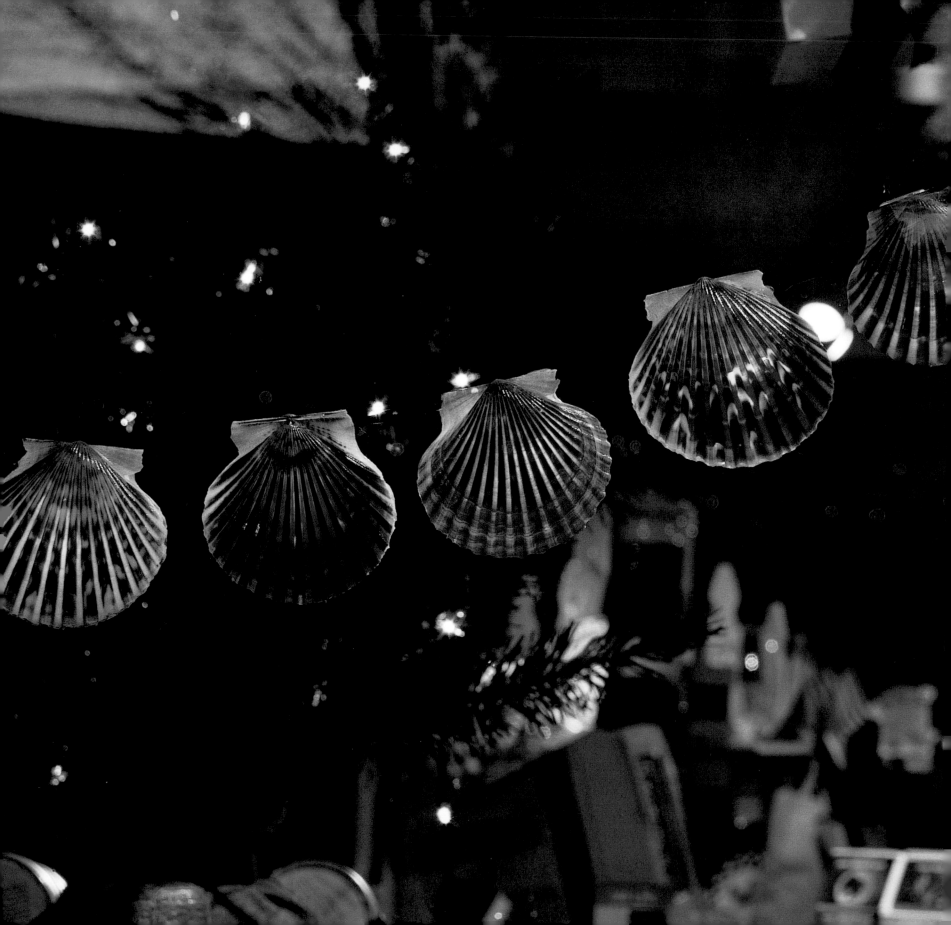

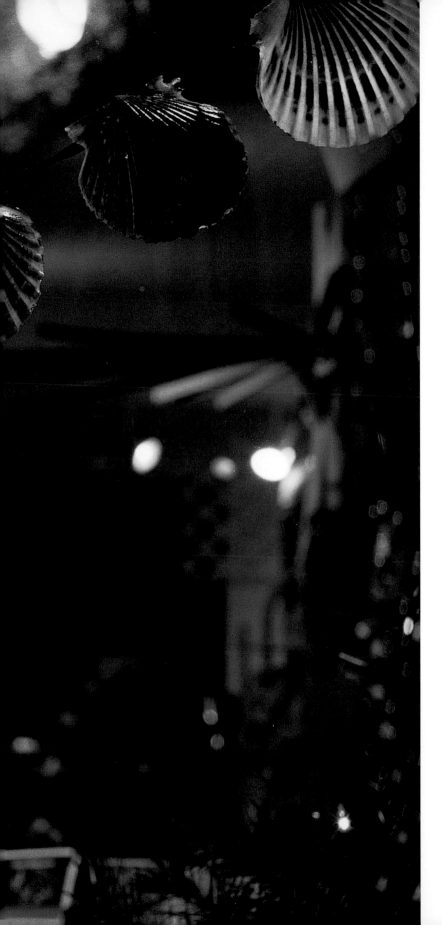

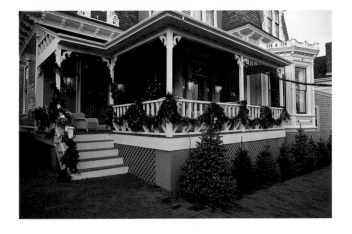

Christmas is my thing. It's lovely

here and not all neon.

Jane Lamb, NATIVE

above:
Broad Street

left:
Scallop Shell Lights

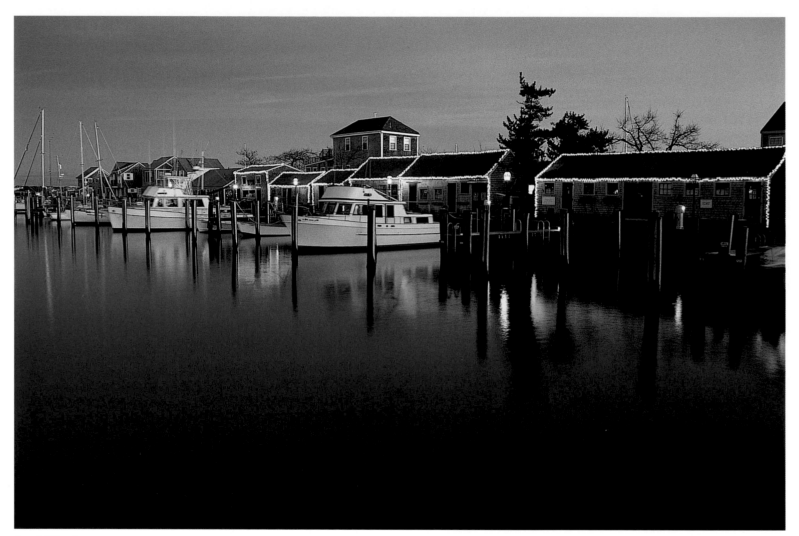

South Wharf

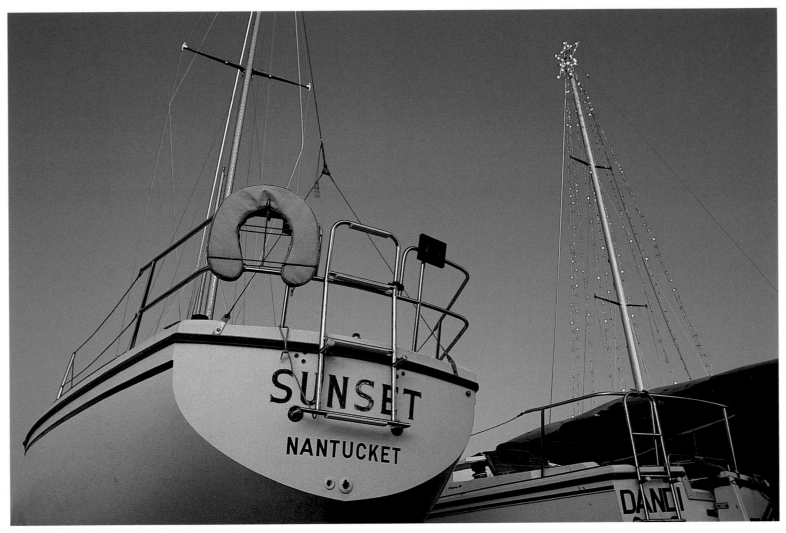

Nantucket Boatyard

There is nothing like the winter night sky when it's cold and clear.

It feels as though the stars are falling on you.

Georgia Ann Snell, MINISTER

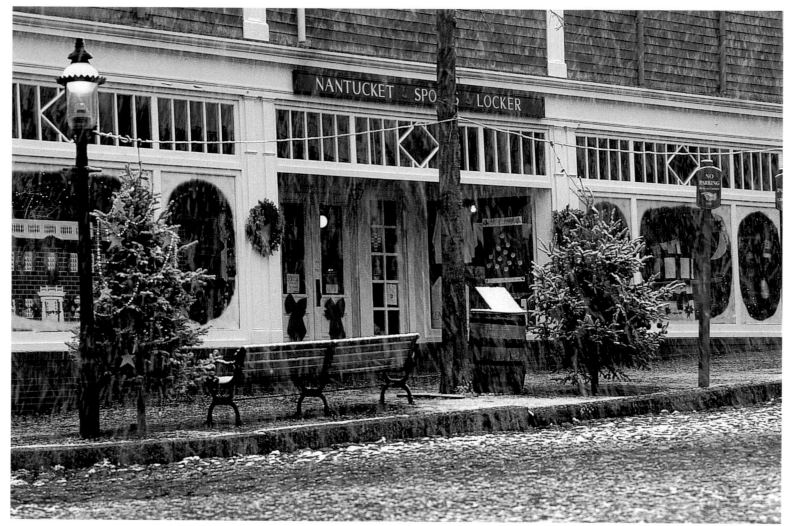

Main Street

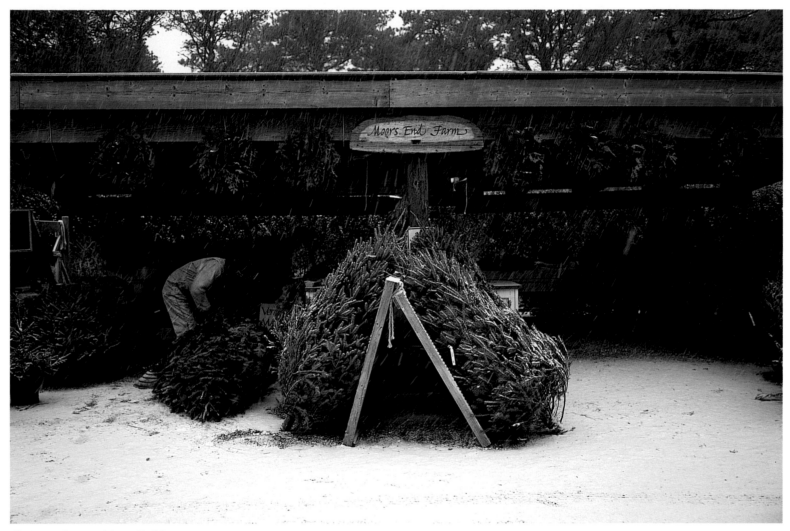

Christmas Trees at Moors End Farm

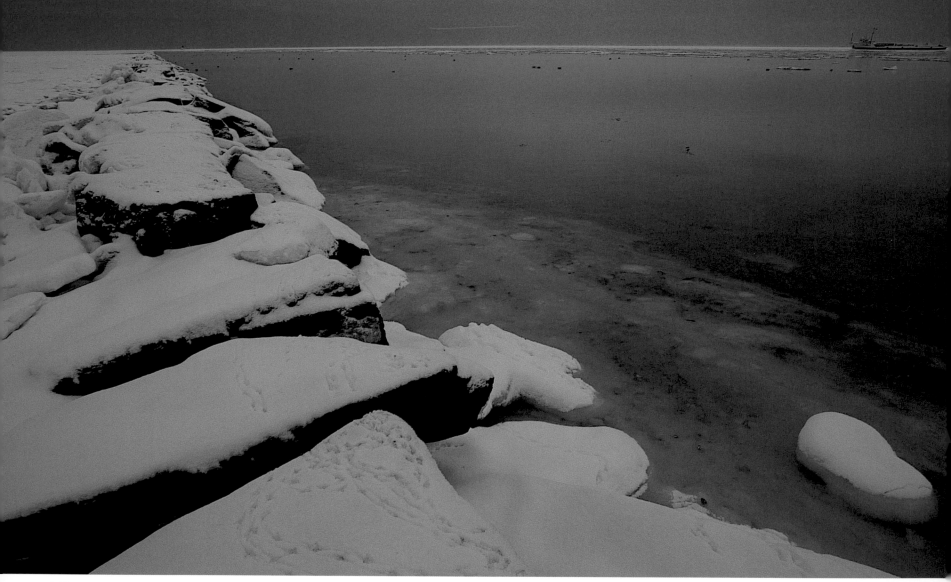

Jetties

You feel like a mother or a father. You feel like Nantucket is something that you need

to nurture and protect and keep.

Finn Murphy, SELECTMAN

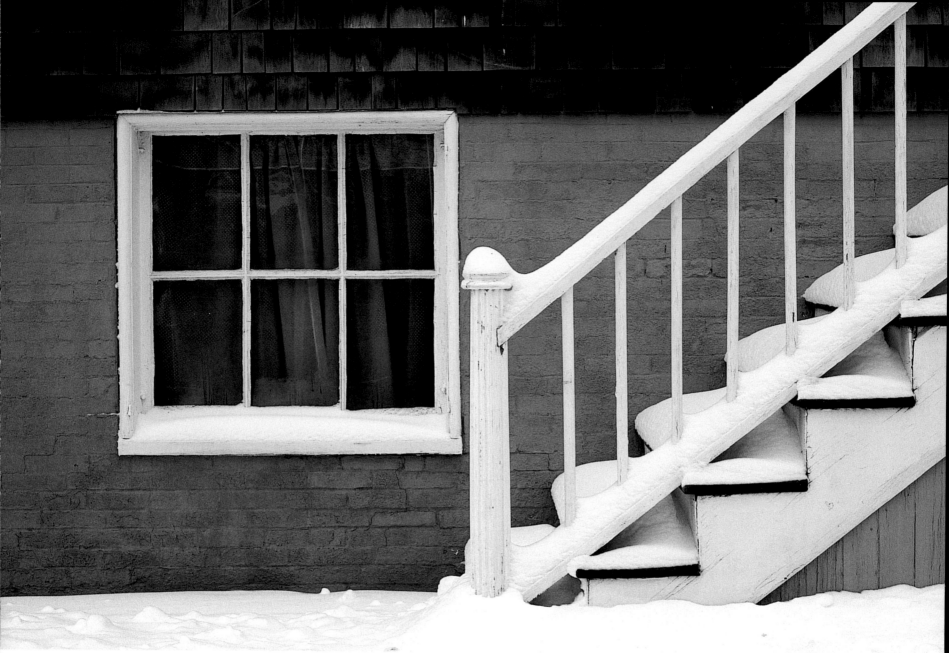

Stairwell

Jetties

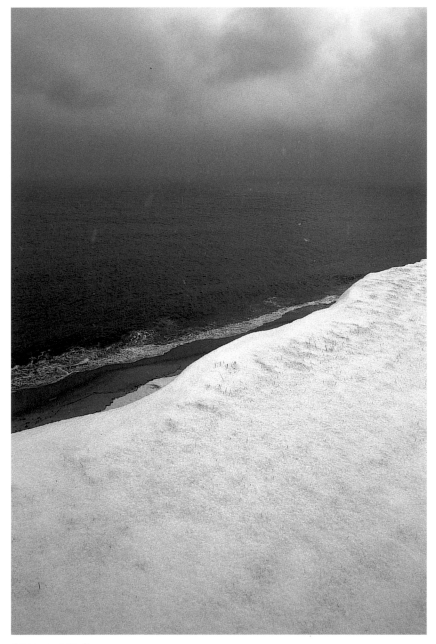

Siasconset Bluff

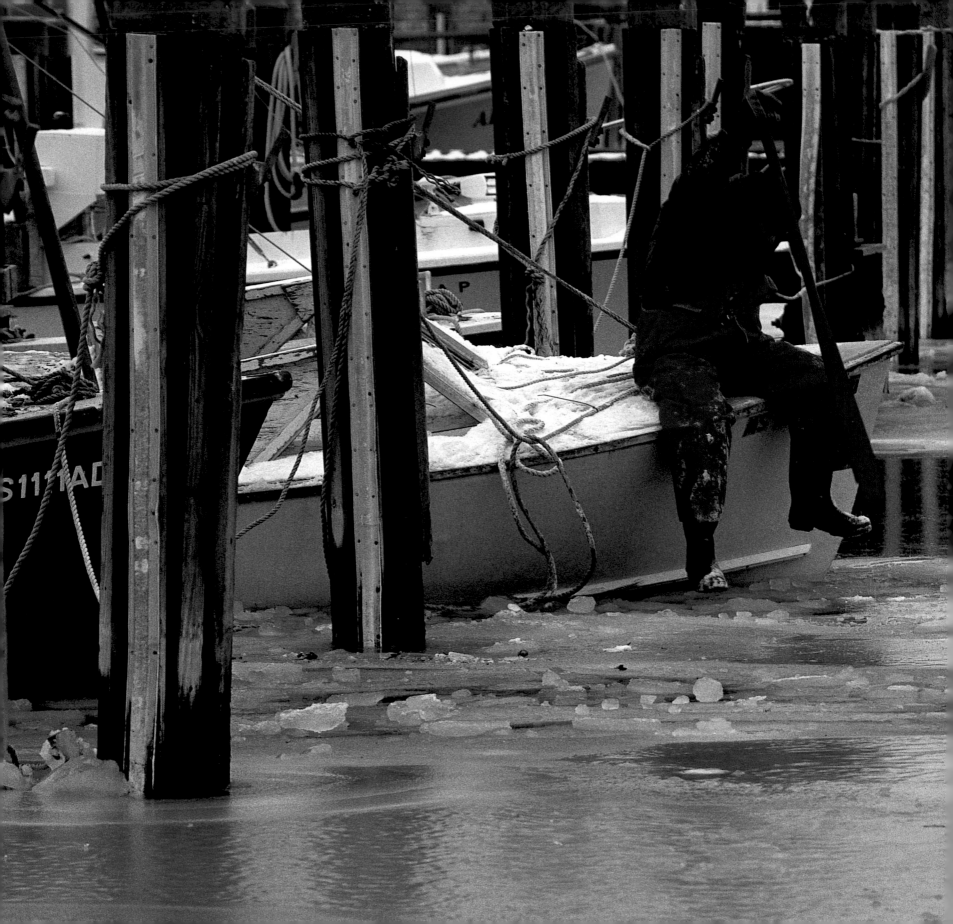

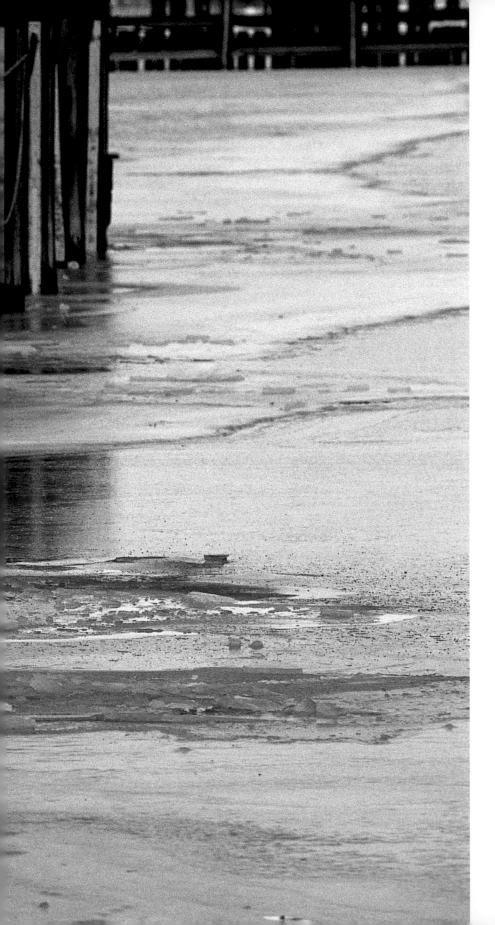

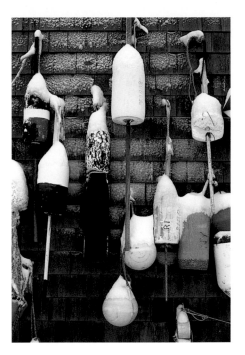

I grew up by the ocean and I feel defined by the landscape. If you are from the desert you are part desert. If you are from the ocean you are part ocean. So I'm probably part ocean.

Robert McKee, ARTIST

above:
Buoys

left:
Scalloper Breaking Ice

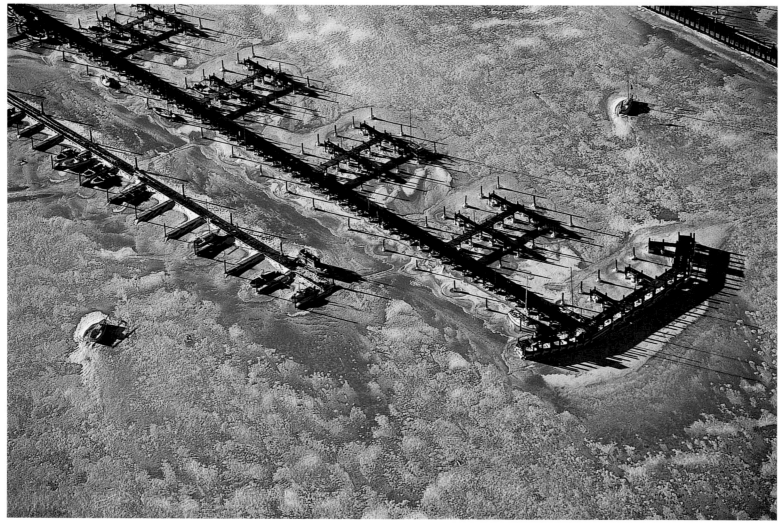

Town Wharf

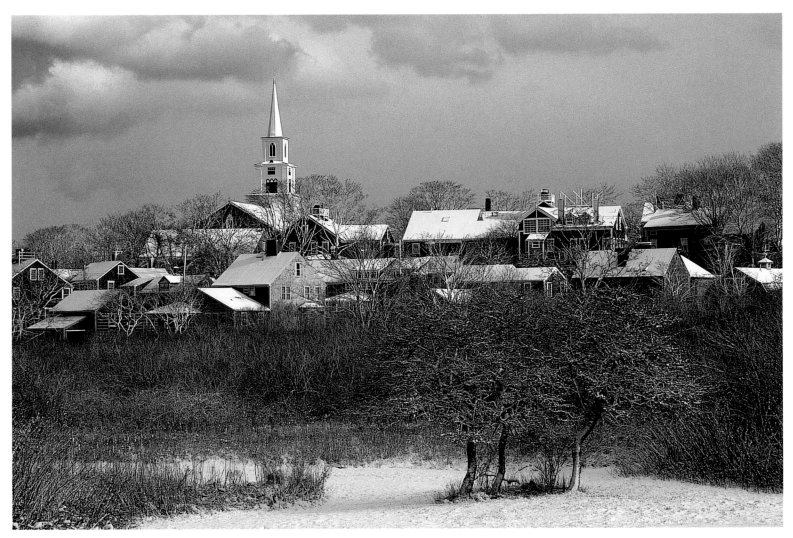

The Congregational Church

One of my friends said that Nantucket is a great place to live, if you can leave anytime you feel like it.

You can't always do that in the winter, so you have to change your attitude. It's a state of mind.

Bob Mooney, HISTORIAN

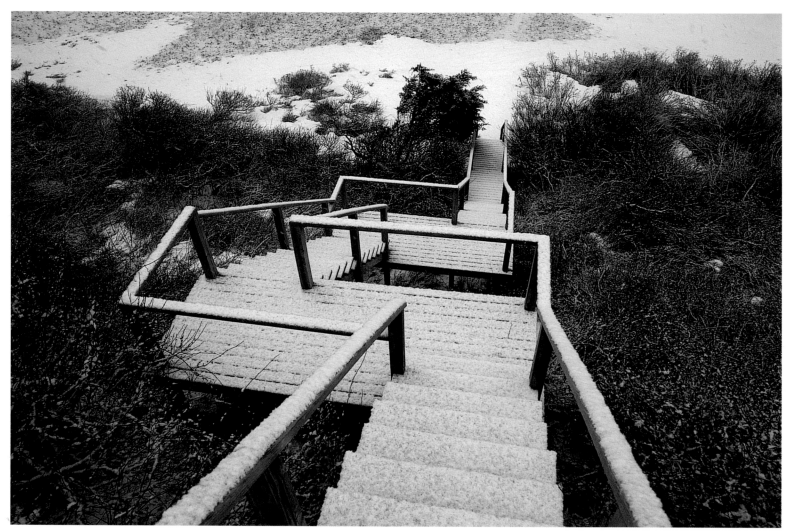

'Sconset Bluff

If you tell people you live on Nantucket year-round, they look at you like you have three heads.

"What do you mean you live there year-round?"

Tom Bresette, FATHER

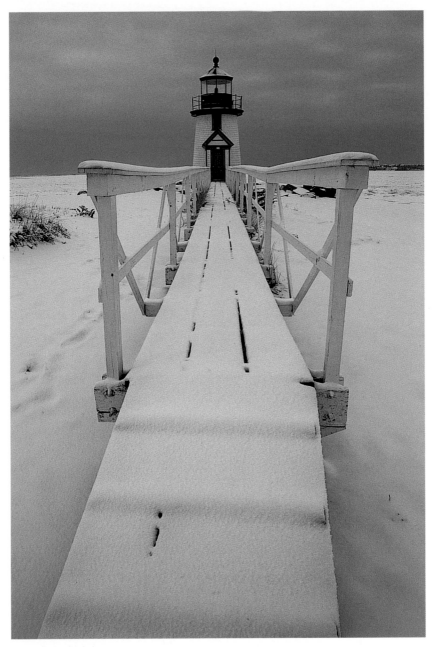

Brant Point Lighthouse

Winter is the time when my sense of belonging intensifies, because it is stark and cold and we are so obvious in contrast to the light and the quiet.

Maia Gaillard, FORMER CHAMBER OF COMMERCE DIRECTOR

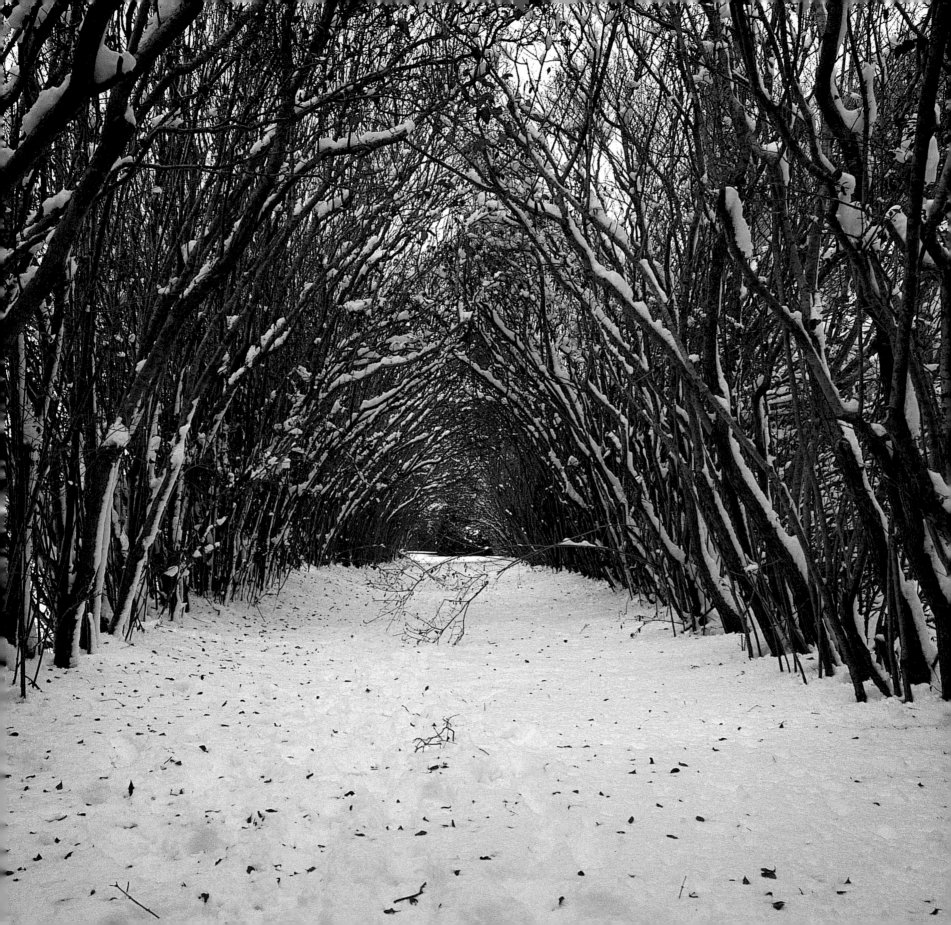

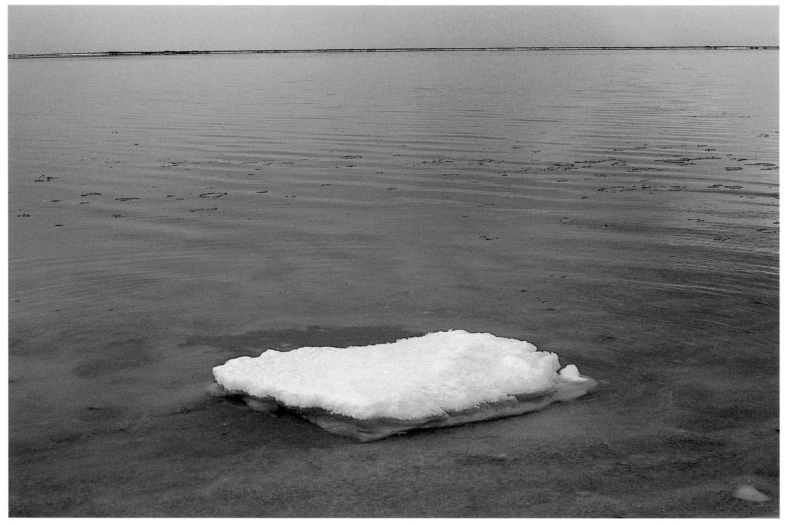

Pocomo Ice Floe

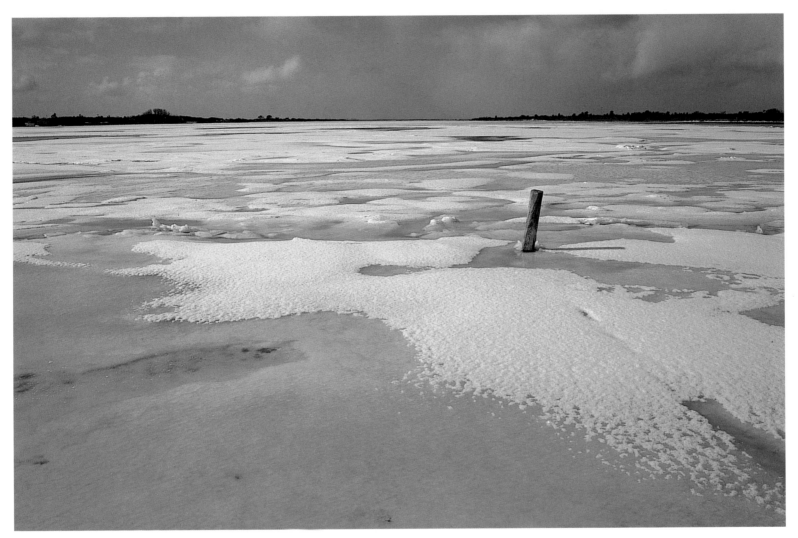

Polpis Harbor

It's islomania. It's about finding islands irresistible and not being able to live anywhere

that isn't surrounded by water.

Christie Cure, THEATER FACILITATOR

following pages, left:
Prospect Hill Cemetery

following pages, right:
Madaquecham

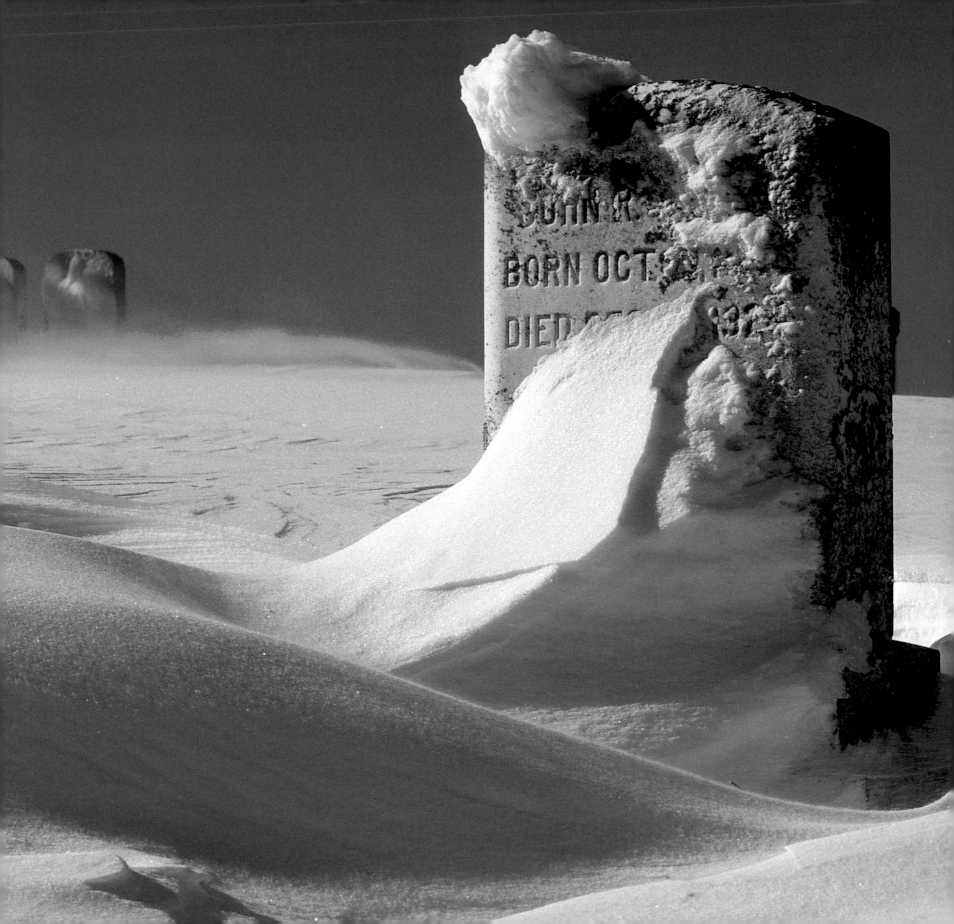

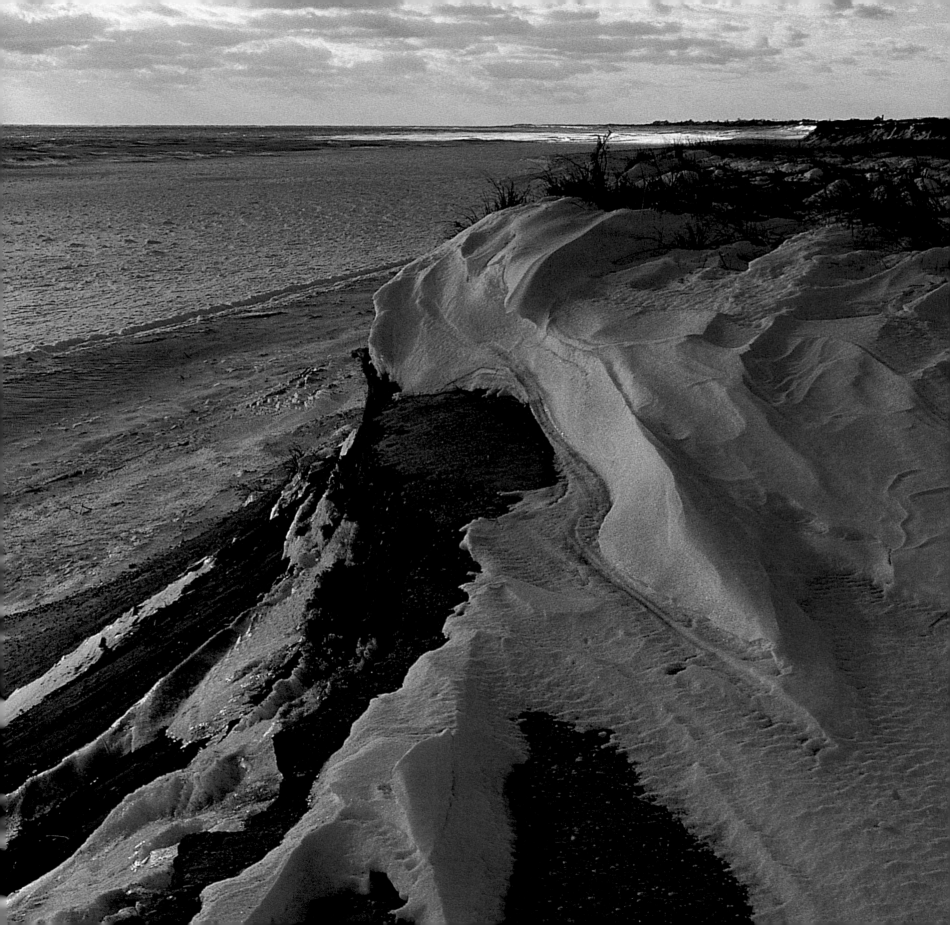

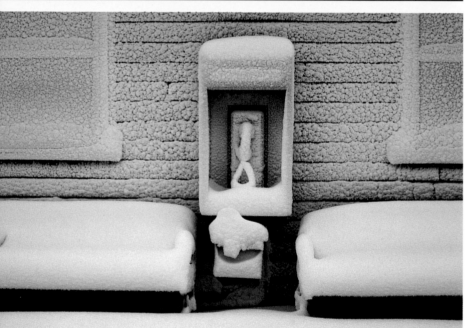
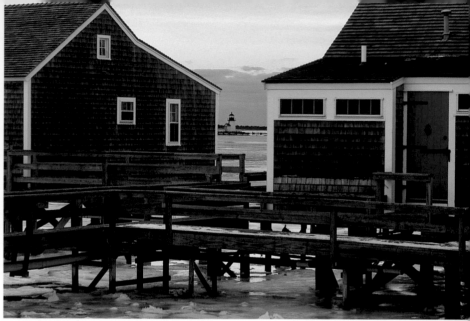
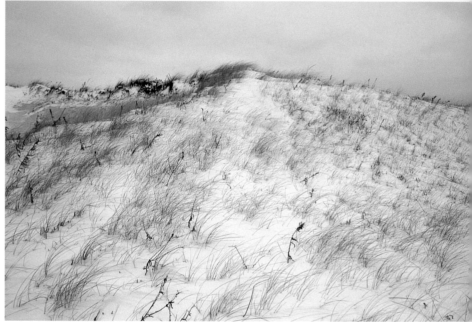
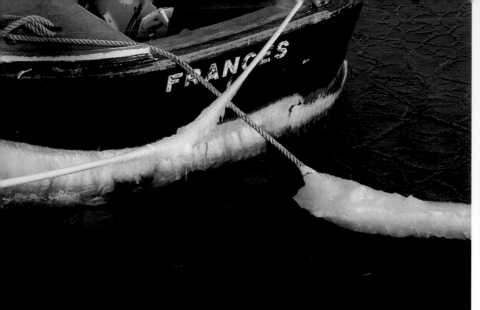

clockwise from upper left:

Frances

Old North Wharf

Jetties Swings

Gibbs Pond

Polpis

'Sconset Window

Jetties Dunes

Winter Pay Phone

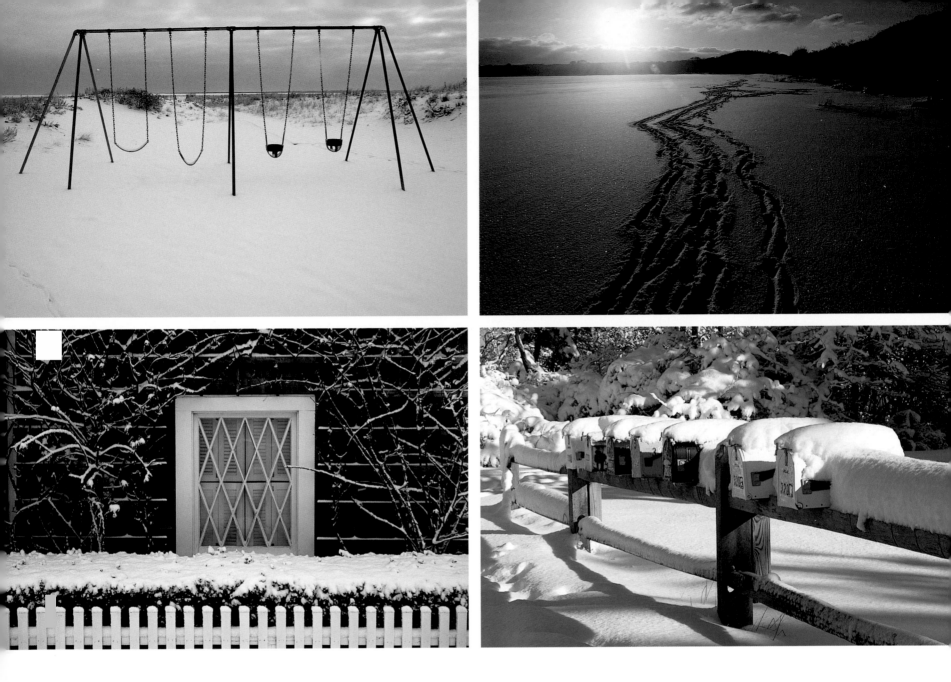

If you live here you get used to the idea that everything won't be at your fingertips all the time.

There are times there is no mail. There are times when the bread runs out at the grocery store. It's no big deal.

Living on Nantucket is an experience, because we are ruled by weather. It breeds patience.

Georgia Ann Snell, MINISTER

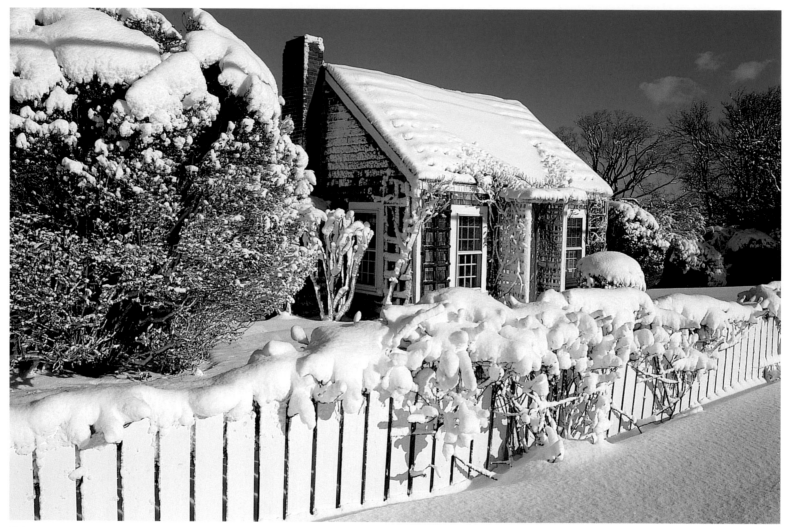

Polpis

Nantucket with a fresh blanket of snow is about the most

beautiful thing you'll ever see.

Michael Kopko, INNKEEPER

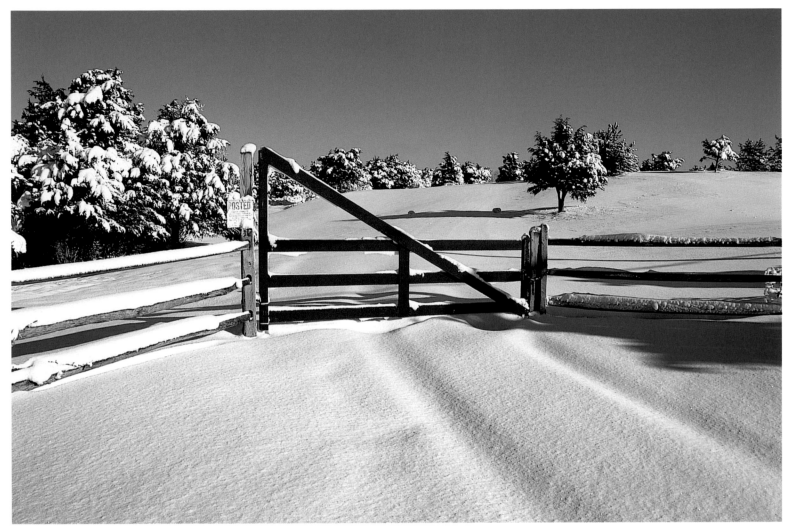

Polpis

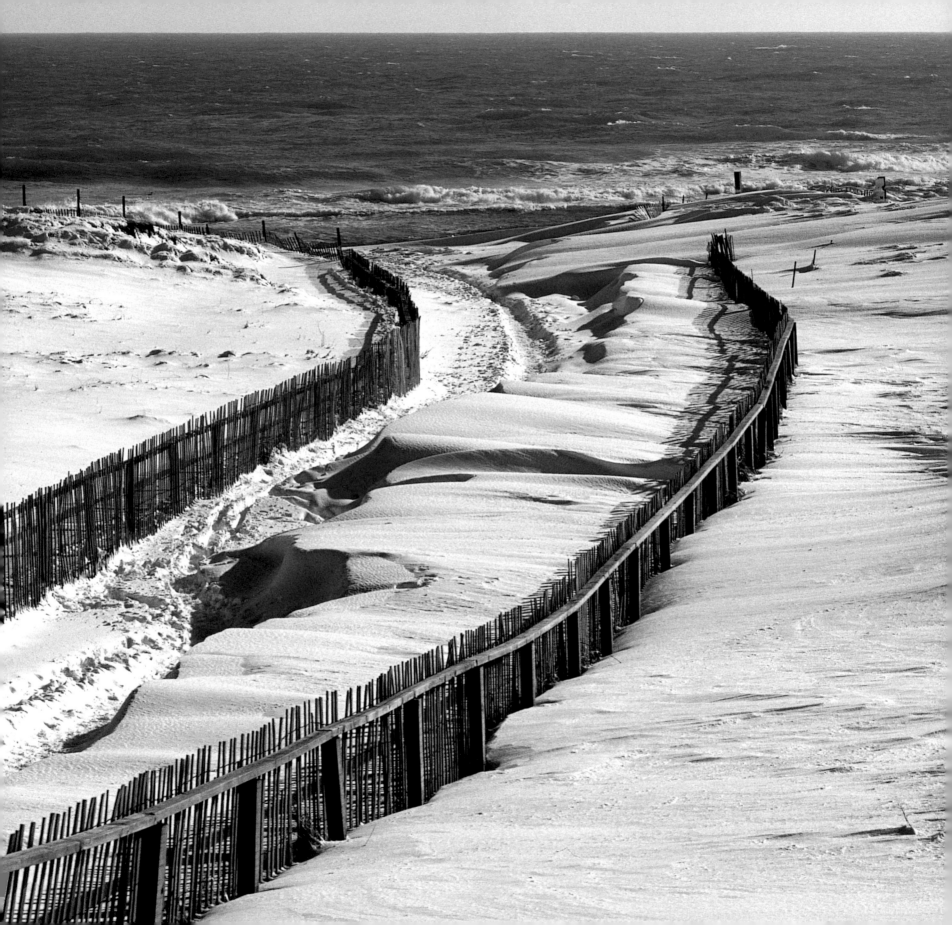

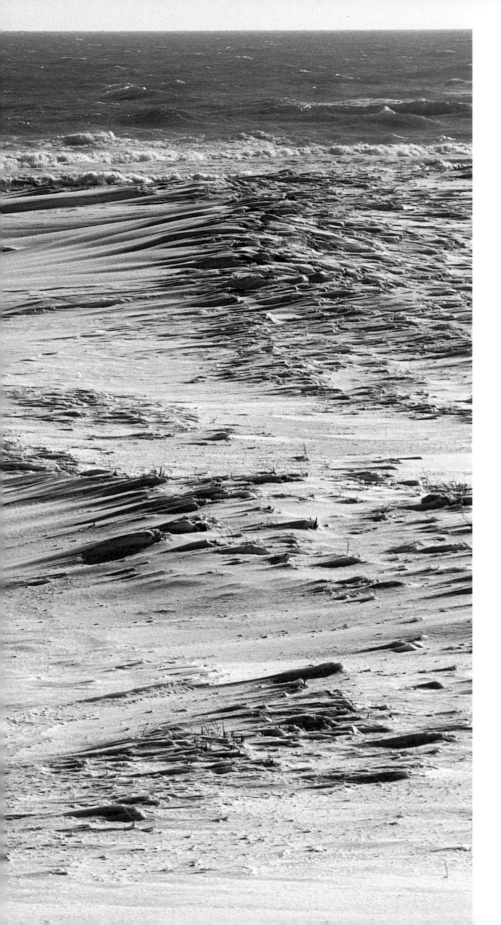

I'm a New Englander, and you have to hate the winter. It's a love-hate relationship. Winter in New England is like talking about your family. I can say, "I hate winter on Nantucket," but if anyone else tells me the weather is terrible, then I have to argue with them.

Michael Kopko, INNKEEPER

Surfside Beach

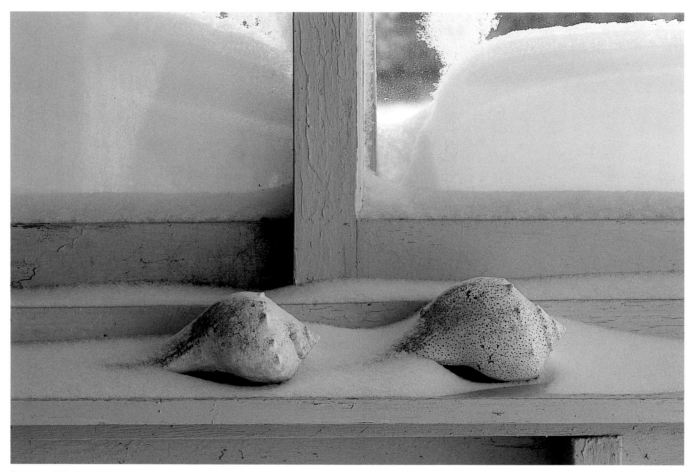

Madaket Windowsill

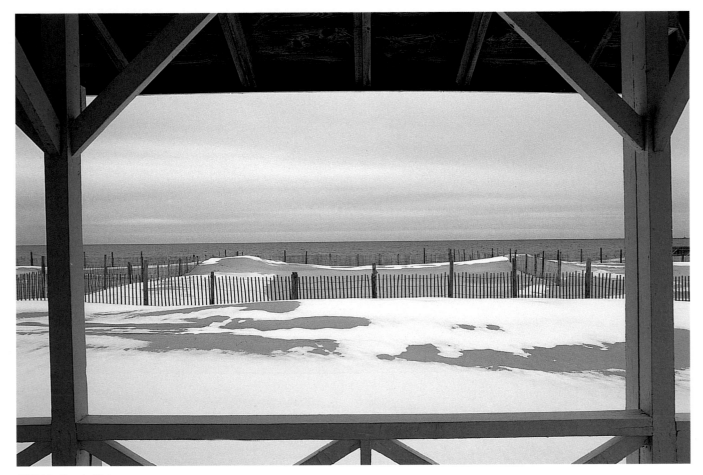

Cliffside Beach Club

I love the winter here. You get to see the bones of the place. The houses stand out in such precise profiles

and the land is bare, without embellishment, and it is restful.

Libby Oldham, EDITOR

Frozen Cranberries

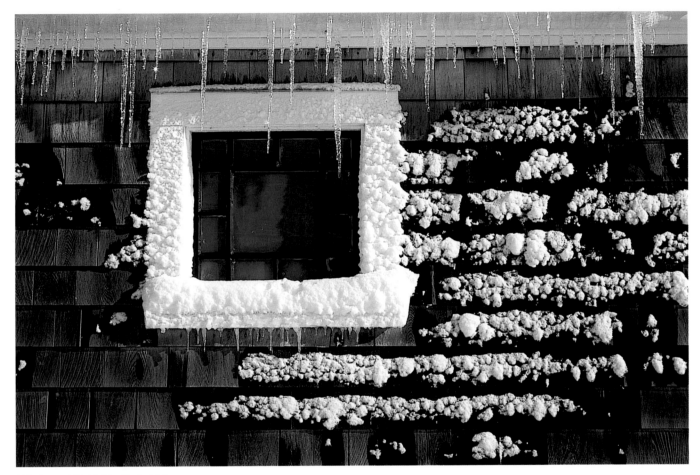

Window of Lightship Basket Museum

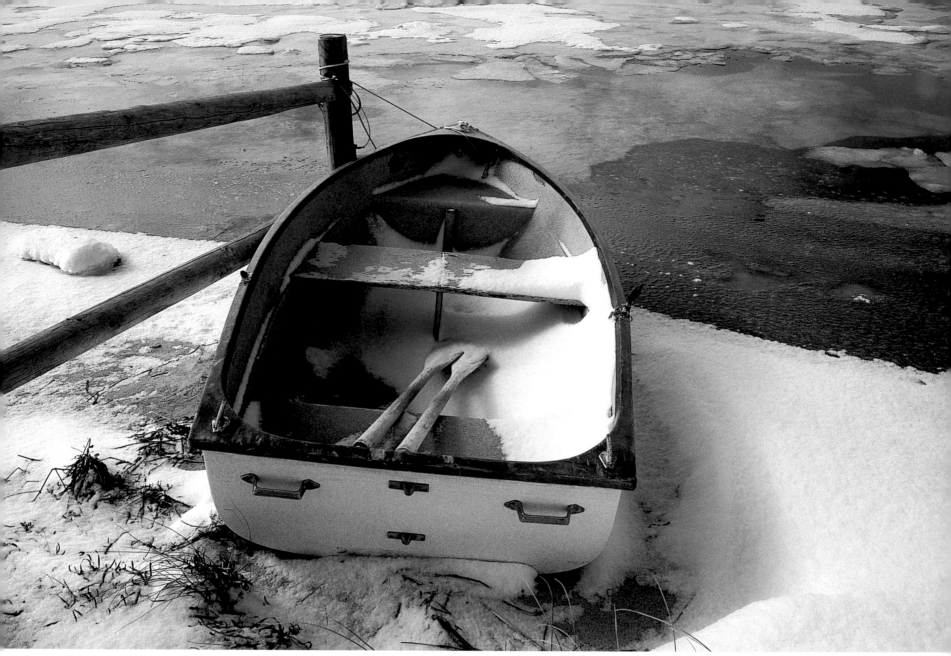

Polpis Harbor

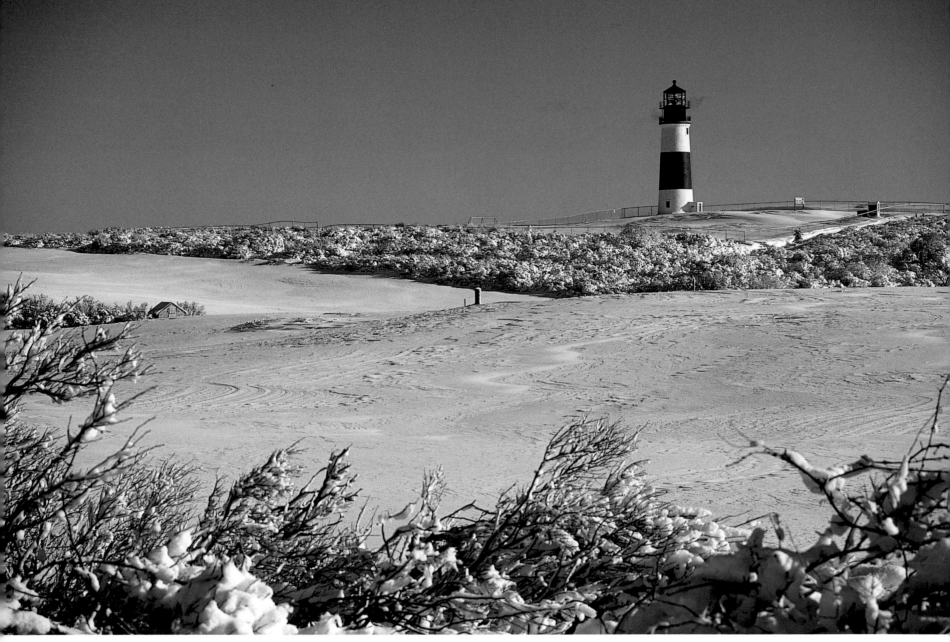

Sankaty Head Lighthouse

You say you are from Nantucket, and people think you are somehow special. They are always curious. . . .

"What's it like in the winter?" I say, "I'm sorry, that's classified information."

Steve Sheppard, EDITOR AND WRITER

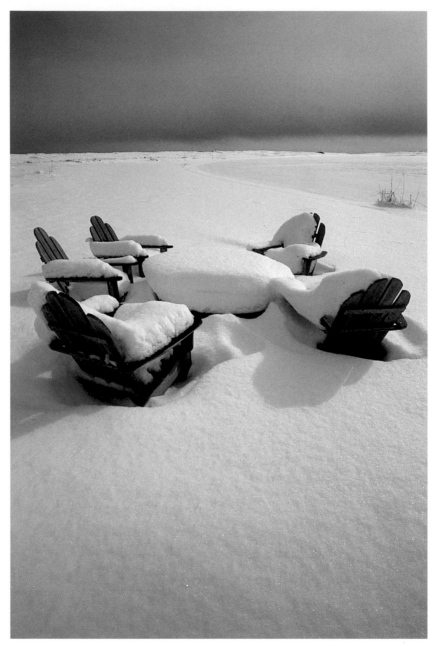

Quidnet Adirondacks

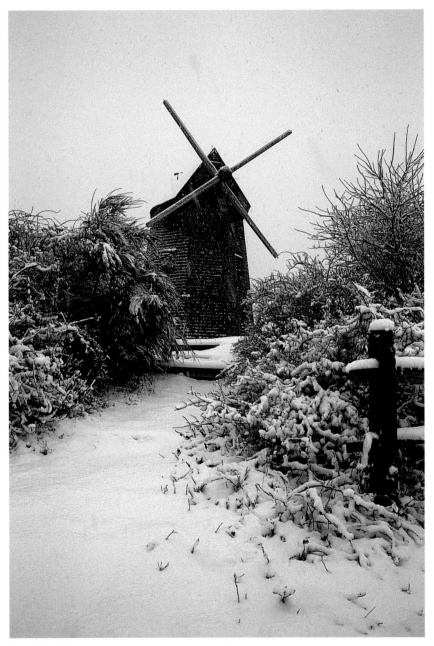

The Old Mill

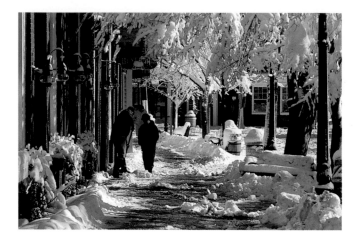

I think to describe Nantucket you would use the word "community." I love the weather and I love the fact that it's an island and I love the isolation and the pace; but most of all, I love being able to walk down the street and know everyone.

Tom Bresette, FATHER

above:
Main Street

right:
Main Street

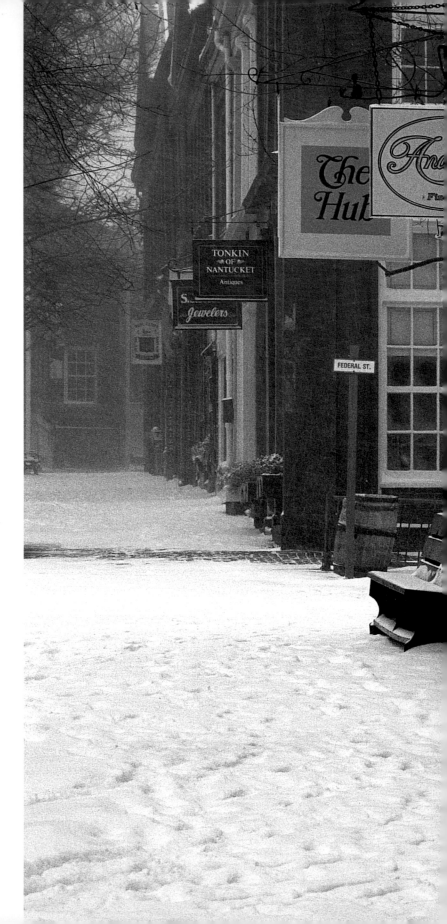

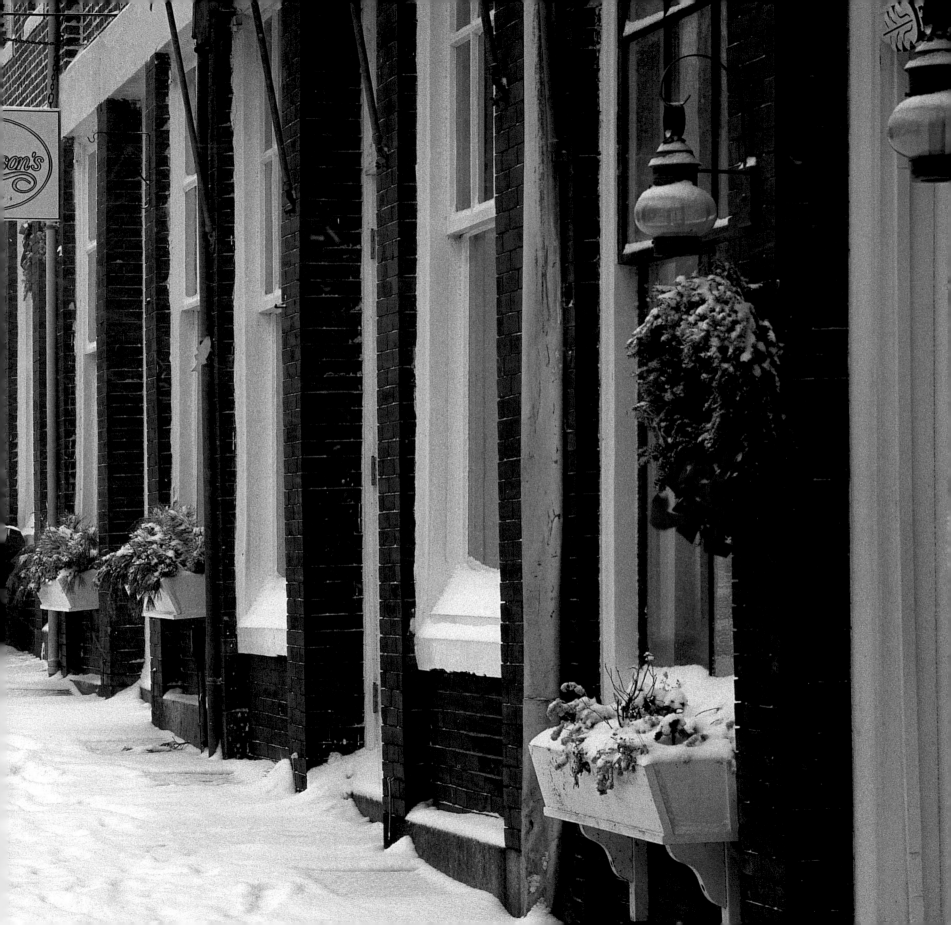

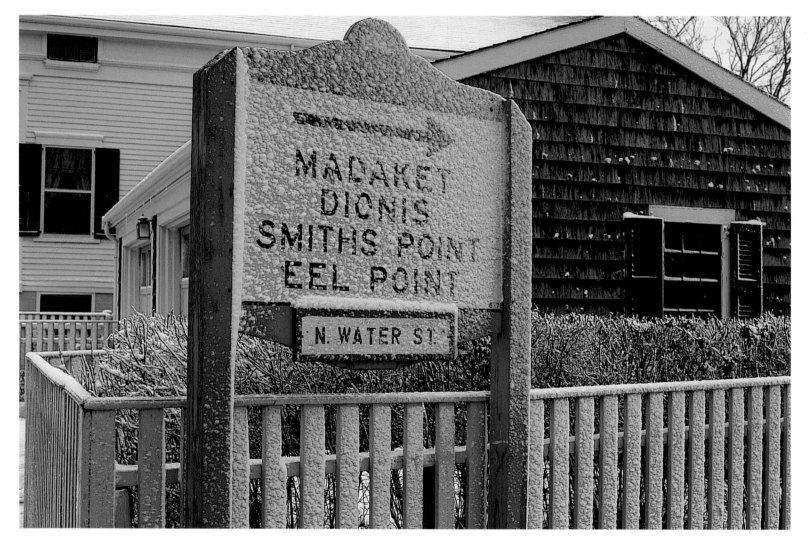

MADAKET
DIONIS
SMITHS POINT
EEL POINT

N. WATER ST.

North Water Street

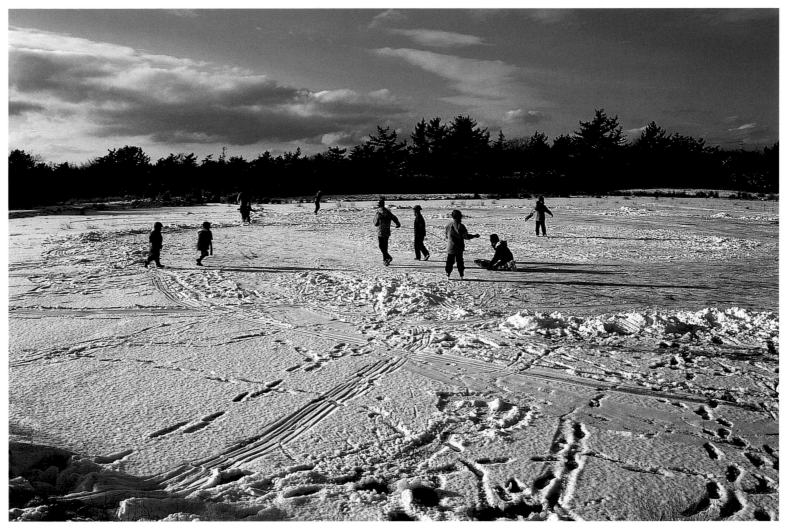

Ice Skating, Windswept Bog

If you're not curious, and if you don't know how to entertain yourself, Nantucket is not for you.

That's what is so special about it. I've been very, very restless here, but never bored.

Christie Cure, THEATER FACILITATOR

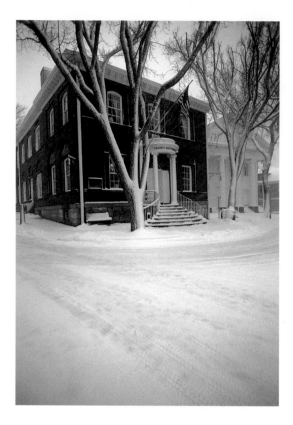

Winter is long here. You need to be able to get along with yourself to survive. I don't think it has to do with Nantucket so much as what's inside an individual.

Finn Murphy, SELECTMAN

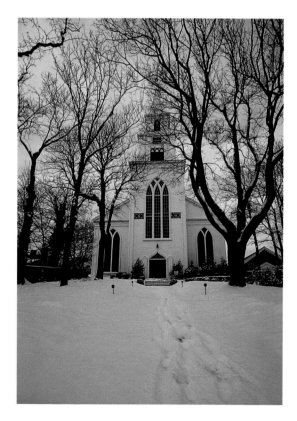

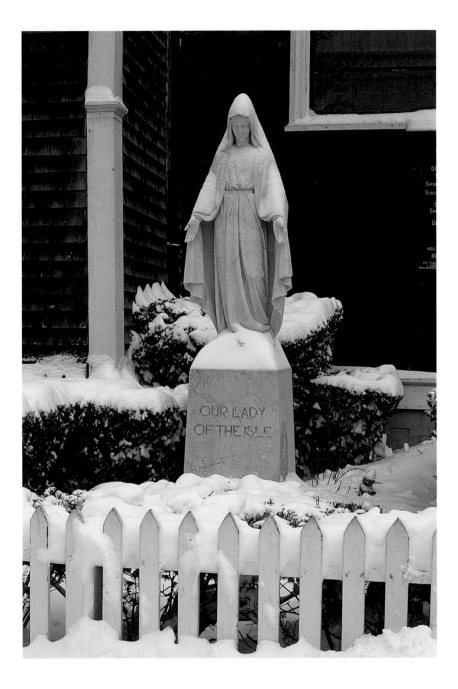

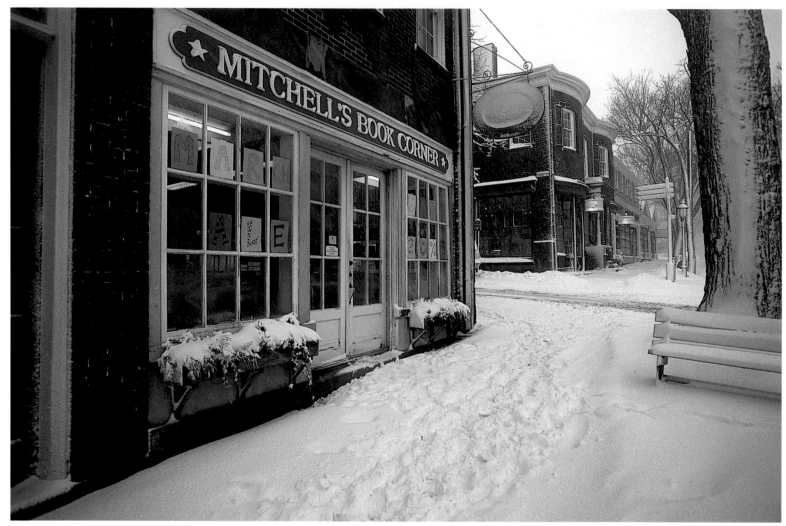

Main Street

The Nantucket people know enough to keep a loaf of bread

and a can of something on the shelf.

Jane Lamb, NATIVE

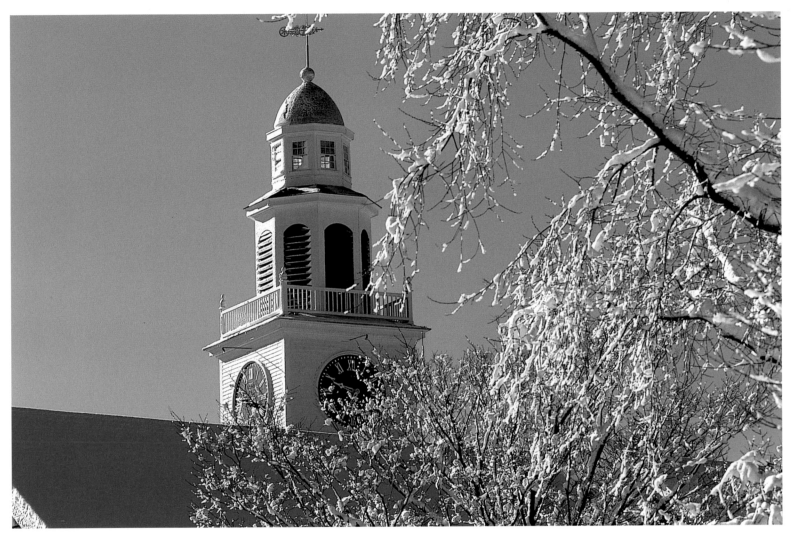

Town Clock

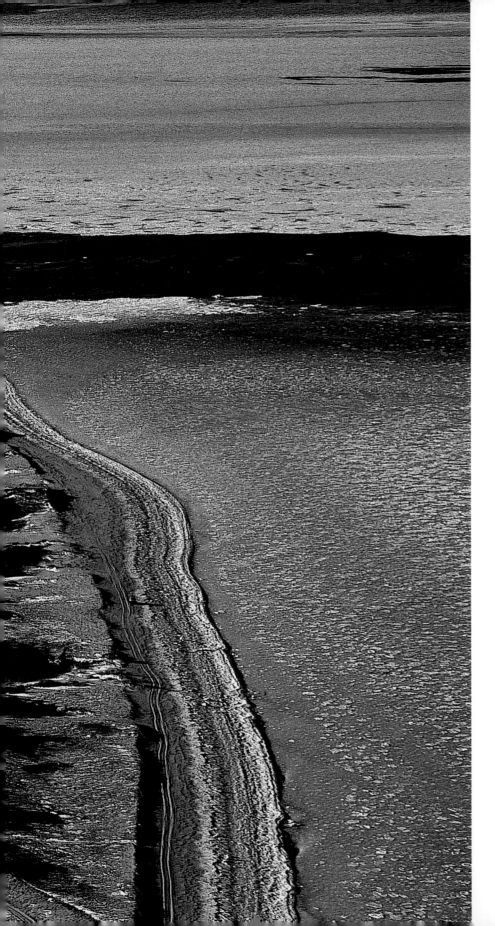

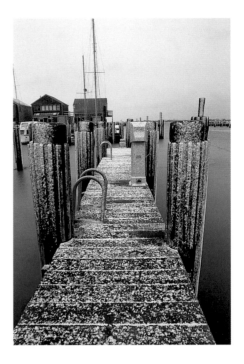

Some people find comfort from mountains or deserts—from vast expanses of land—others have to live by the ocean. It's what makes them feel calm and serene and safe.

Christie Cure, THEATER FACILITATOR

above:
South Wharf

left:
Great Point

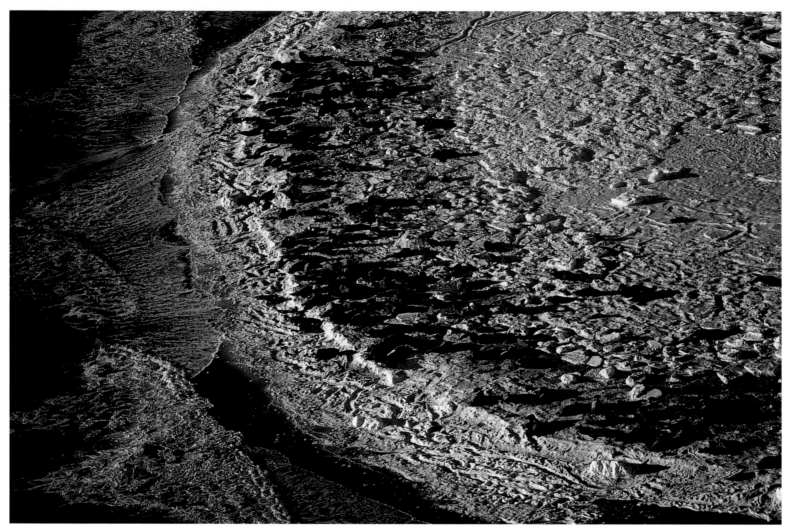

Seals On Esther Island

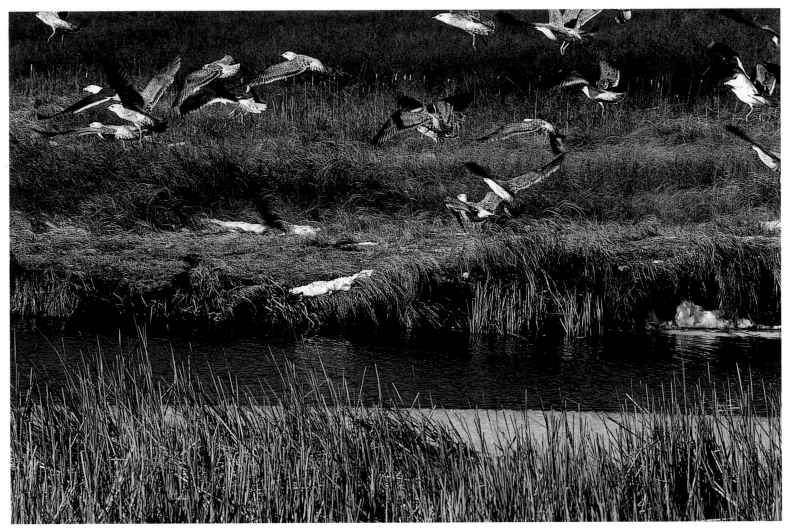

Polpis

Nothing can be taken for granted here—the weather, your food source. You have to rely on your wits.

I worry about everyone wanting things at their fingertips, because that makes things ordinary.

Christie Cure, THEATER FACILITATOR

following pages, left:
South Wharf Slips

following pages, right:
Center Street, 'Sconset

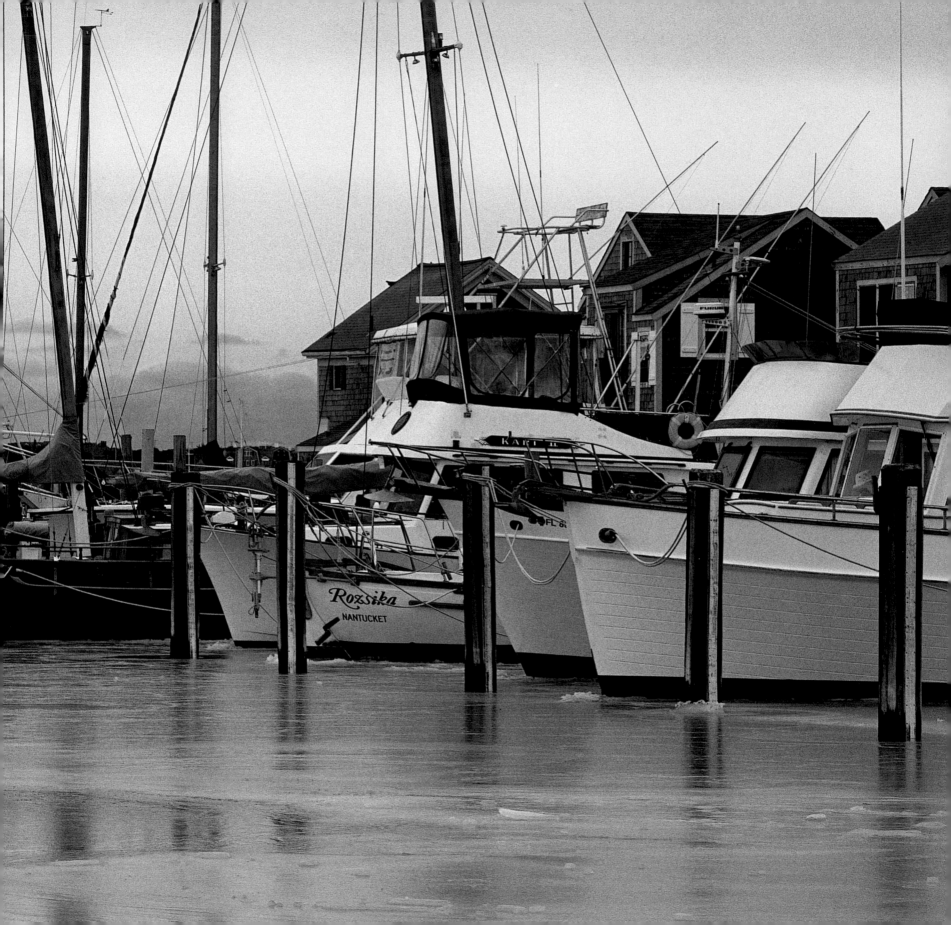

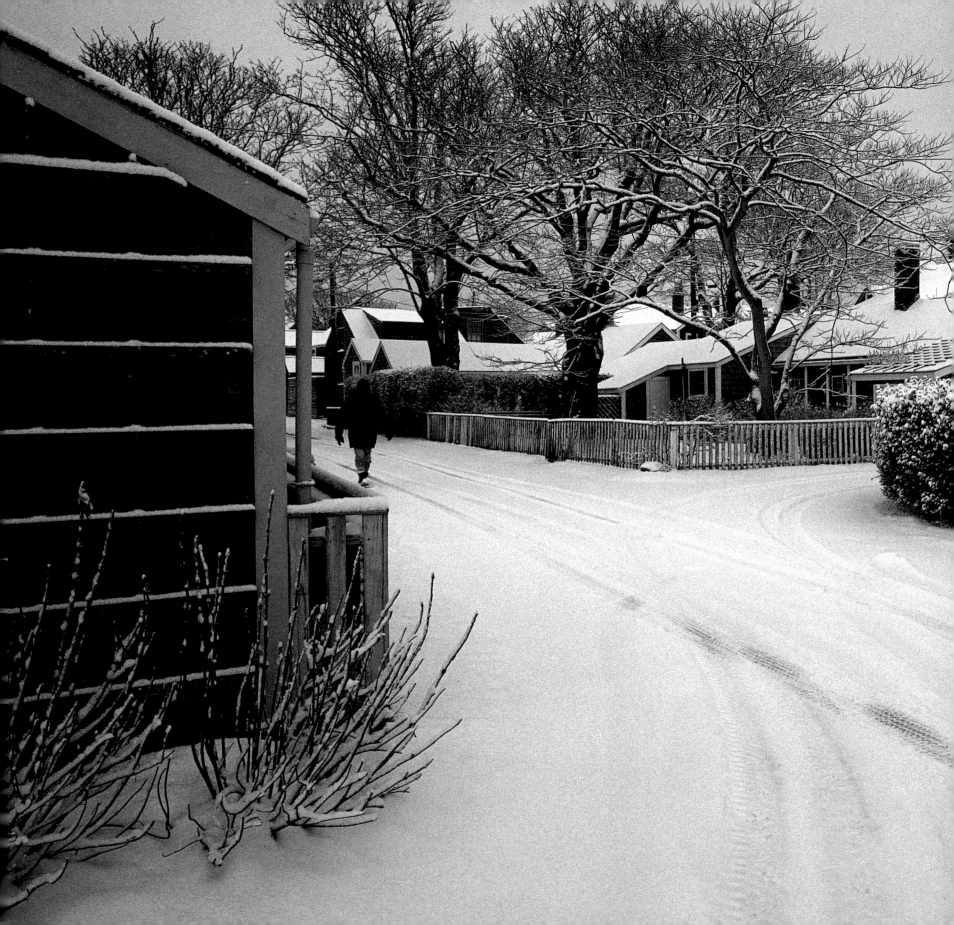

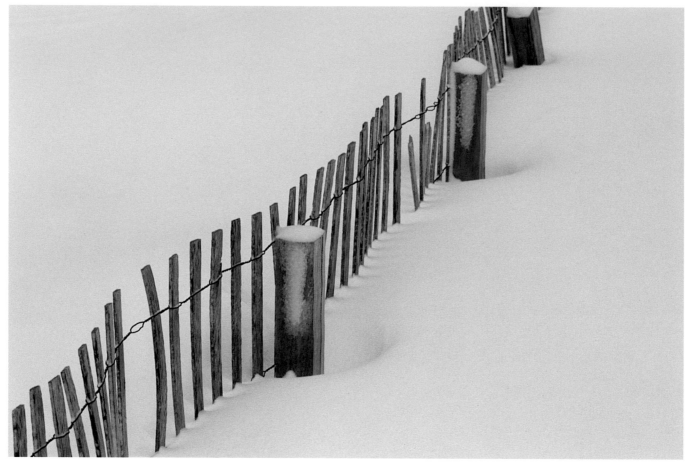

Snow Fence

If you're an introspective person and you spend a lot of time thinking and mulling things over, the winter is a perfect time.

Bill Ferrall, EDITOR

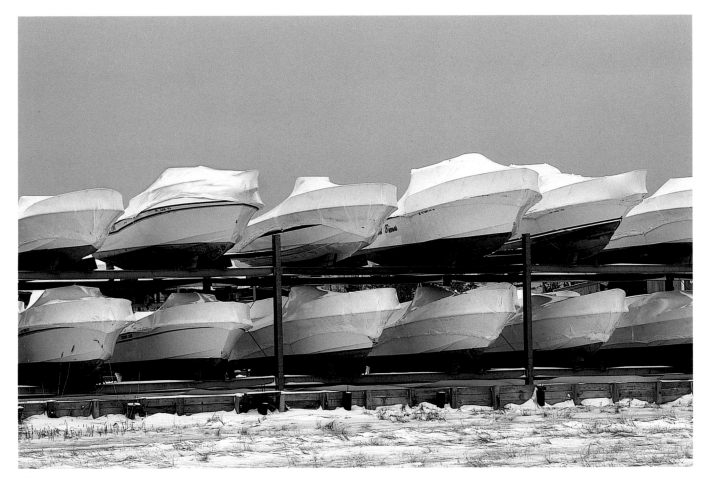

Madaket Marine

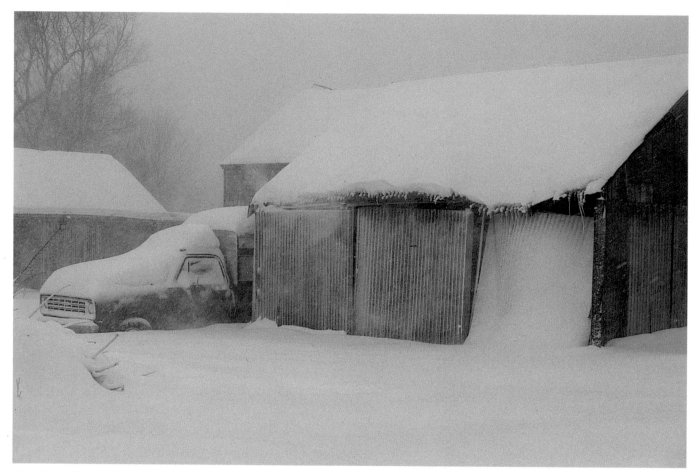

King Street, 'Sconset

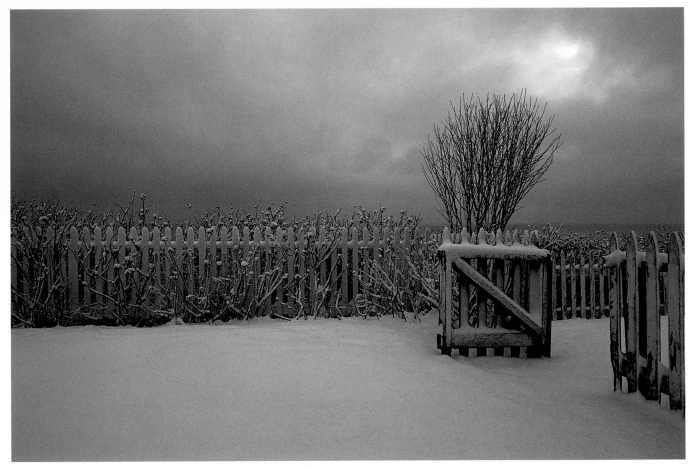

Front Street

Winter is gray. If you don't like gray days then you won't like it here.

That's why Nantucket gets the name "the little gray lady."

Ruth Chapel Grieder, NANTUCKETER

Money gets boring quickly,

but the landscape doesn't.

Christie Cure, THEATER FACILITATOR

Whale Privet Hedge

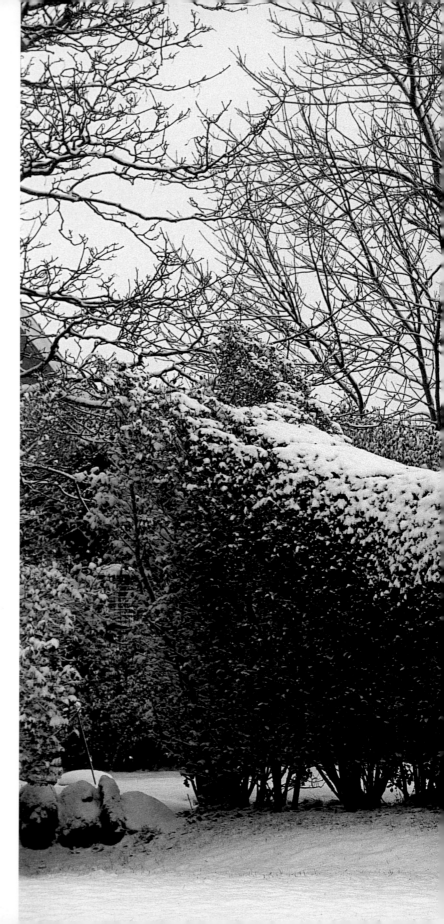

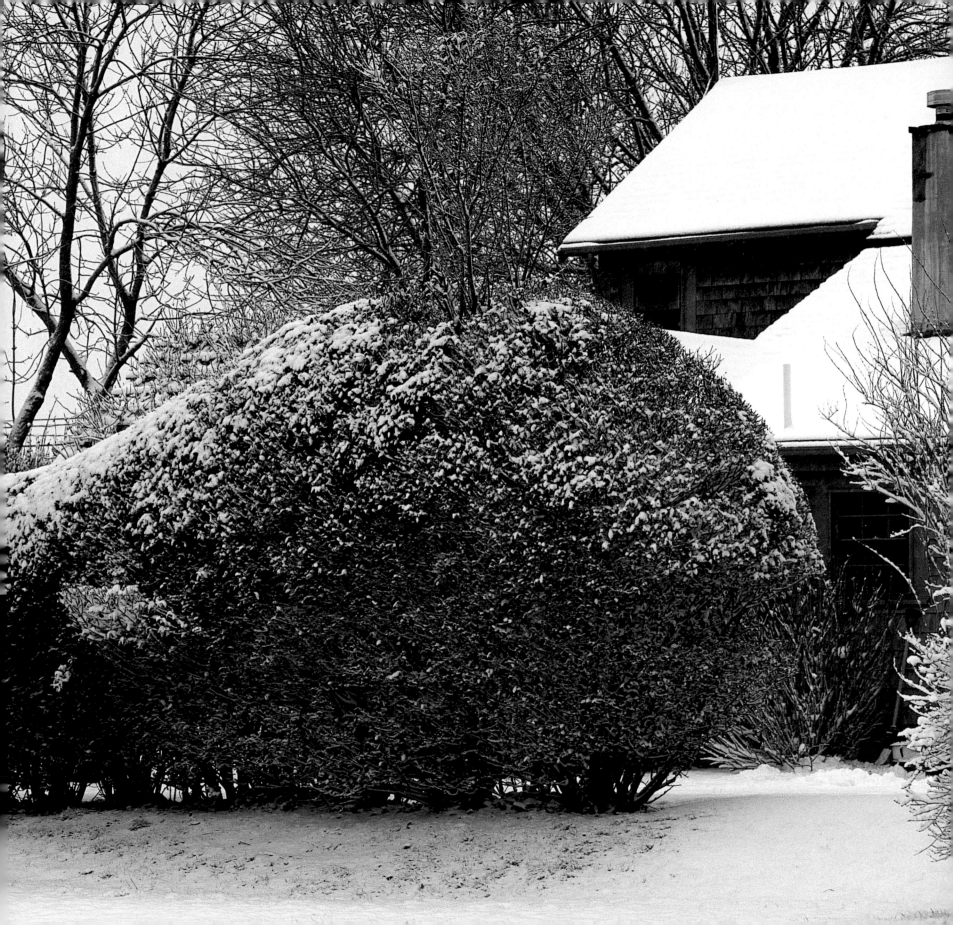

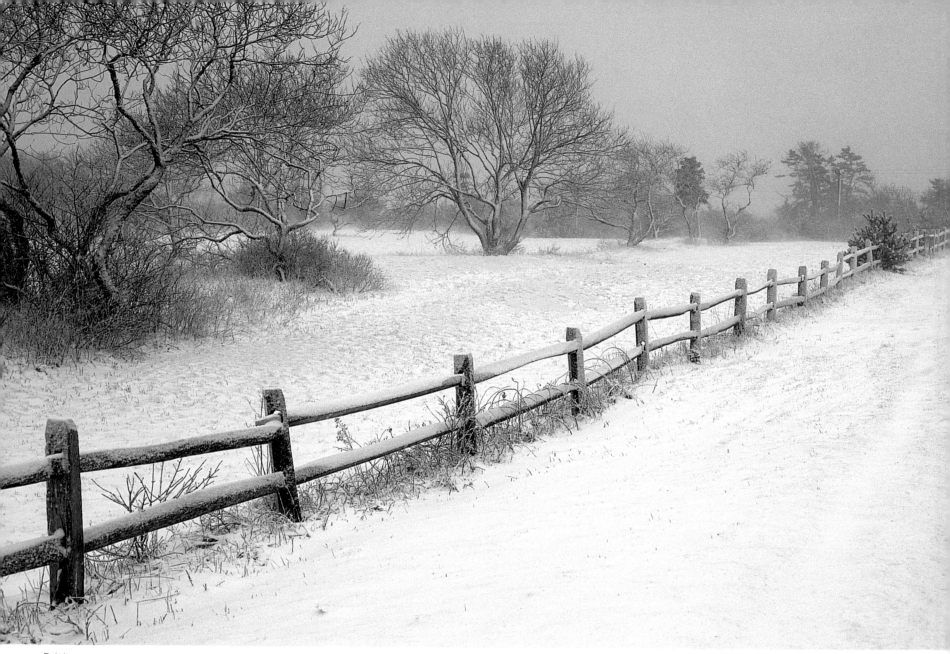

Polpis

I really love every season for different reasons. But if I had to pick one, I'd say winter, because it's

when I really calm down and spend time doing what I want to do for myself. You've got to be pretty

independent and self-sufficient and enjoy solitude and quiet time.

Lucinda Young, LANDSCAPE DESIGNER

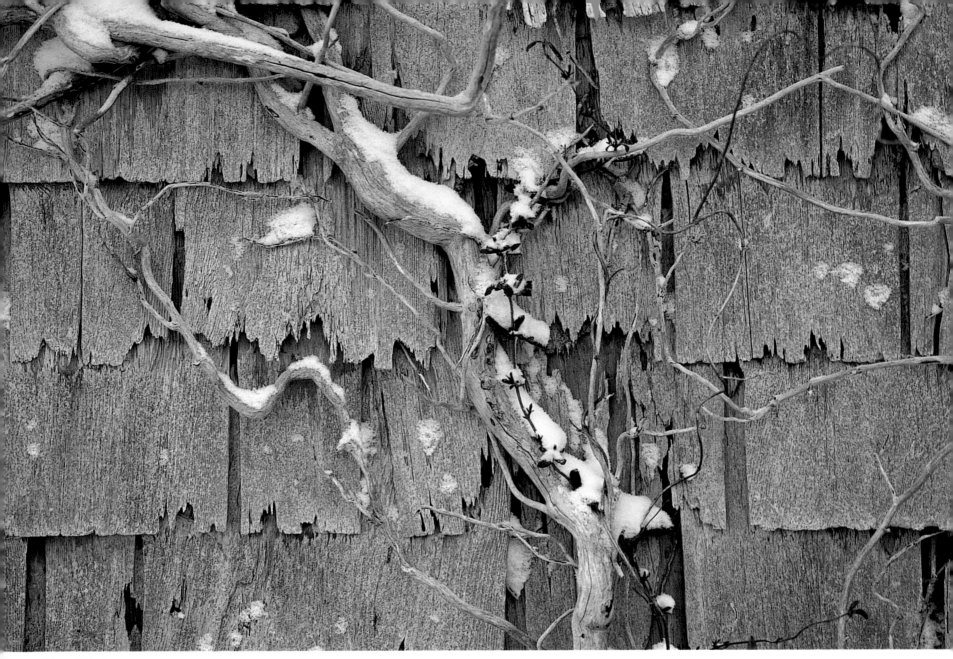

Winter Shingles

Jetties Beach

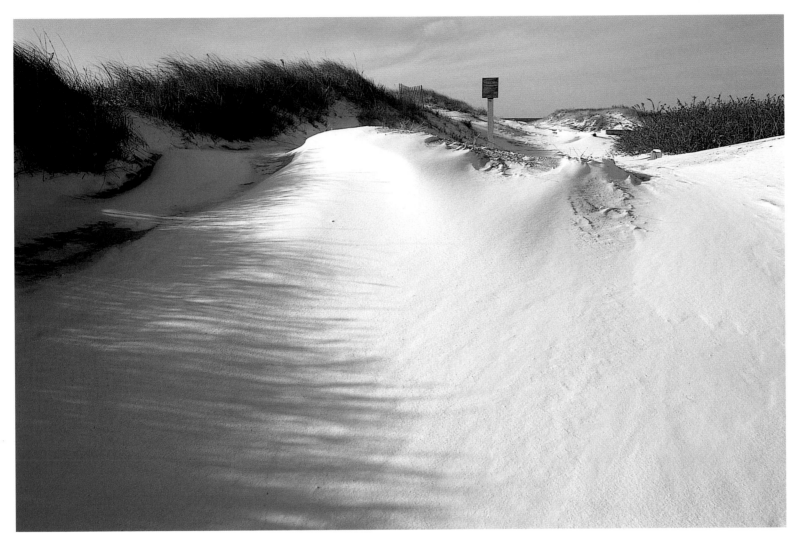

Madaket

I just feel freer here than I feel anyplace else.

Christie Cure, THEATER FACILITATOR

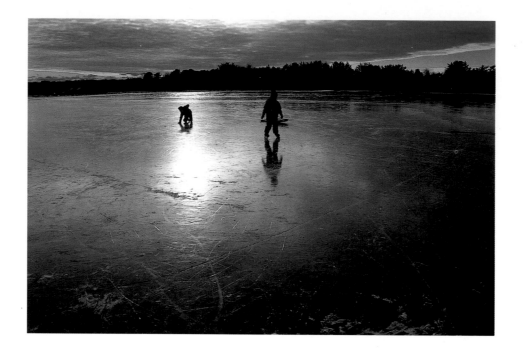

I like the feeling that it's away from everything. Nantucket is a little universe of its own.

Reggie Levine, ARTIST AND FORMER GALLERY DIRECTOR

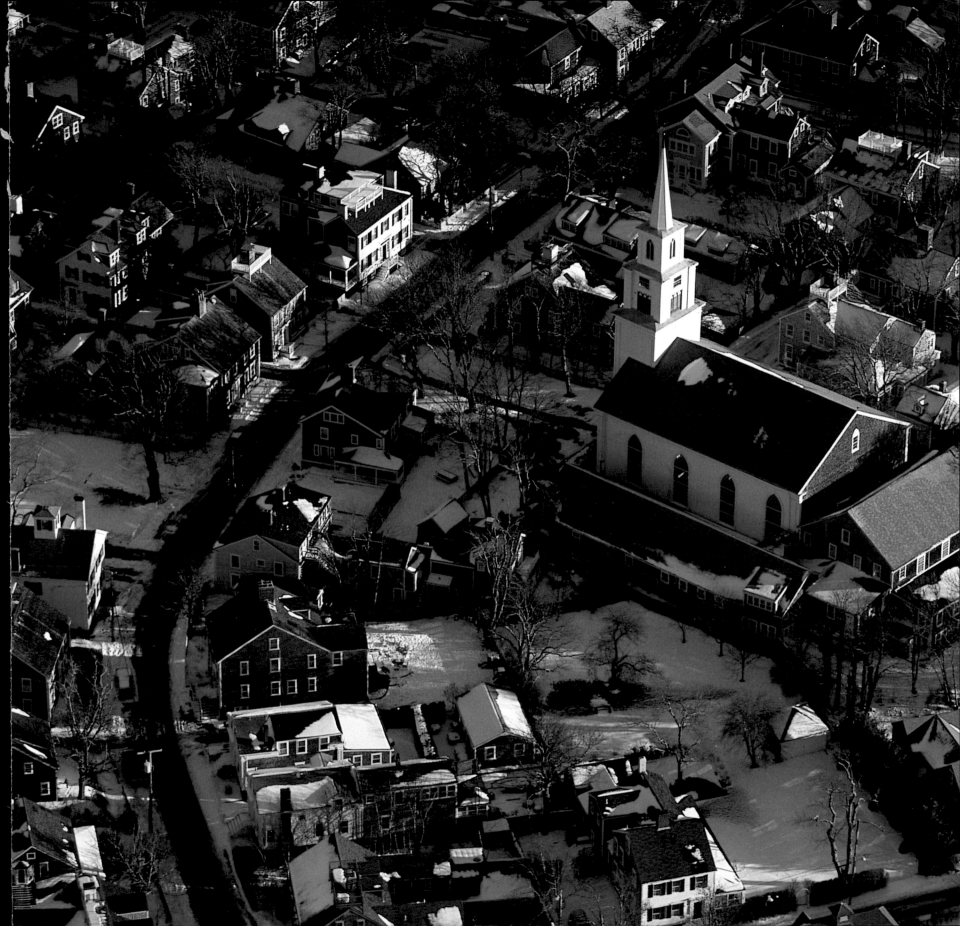

ACKNOWLEDGMENTS

To my husband, Andy Bullington, who has the patience of Job.

To Nathaniel Philbrick, who graciously wrote the introduction during his national book tour for *Sea of Glory.*

To Mimi Beman, Carole Buckley, Jordi Cabre, Sarah Chase, Lydia Christoph, Janet Colby, Alan Costa, Lee Engwall, Chris Hamilton, Lucy and Wilbur Hazlegrove, Bill and Sarah Hazlegrove, Rachel Hobart, Suzanne Keller, Chris McLaughlin, Mary Warren and Don Moffett, Libby Oldham, Alan Rapp, and the Nantucket Lighthouse School.

To the Nantucket Conservation Foundation and the Nantucket Land Bank for keeping Nantucket open and accessible.

And to the people who gave *The Quiet Season* a voice.